EPITOME OF DESIRE

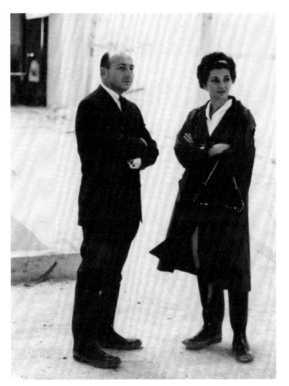

Ray and Patsy Nasher at NorthPark, 1965

# EPITOME
# OF DESIRE

*The Story of the Nashers of Texas
and One of the World's Greatest Sculpture
Collections Created by Their Passion
and Obsession for the Best*

———

ROBERT A. WILSON

DISTRIBUTED BY
UNIVERSITY OF TEXAS PRESS, AUSTIN

ISBN 0-292-70286-8

FIRST EDITION

*Book design by Mark McGarry*
*Set in Caslon*

ENDPAPERS: Detail of Renzo Piano's cast aluminum roofing system created for the Nasher Sculpture Center, which he likened to a sculpture "whose little eyes are always looking for the northern light."

*For the Nashers*

Looked at broadly, what happened always has meaning, pattern, form and authenticity. One can classify, analyze, arrange in order of importance and judge any or all of these things, or one can simply stand back and view the whole with wonder.

WILLIAM MAXWELL

# ACKNOWLEDGMENTS

First, I thank Ray Nasher for the unsurpassed gift of the sculpture center to Dallas.

I am indebted to Barbara Hawn whose intelligence and hard work helped this book find the light of day. Mike Ritchey's help was crucial. Ellen Gordesky, who oversees the Nasher archives, and Karen Roden were patient and always cooperative during my research. Steve Nash's insights were invaluable. Jennifer Ritchey at the Nasher Sculpture Center helped us immensely with photograph rights and permissions.

To all who gave me their time and energy, thank you:

Diane Ackerman, Joe Barta, Mike Boone, Robert Brownlee, Elliot Cattarulla, Paula Cooper, Lee Cullum, Jean Eisenberg, Dr. Gene Frankel, Ellen Gordesky, Jeremy Halbreich, Donald Hall, Vel Hawes, Marguerite Hoffman Walter Hopps, Glenn Horowitz, Ed Hudson,

Bill Jordan, Ron Kirk, Key Kolb, Dorothy Kosinski, Janet Kutner, Jack Lane, Schatzie Lee, Jim Lehrer, Kate Lehrer, Patricia Loud, Alan May, Jackie McElhaney, Neil McGlennon, Dr. Barry Munitz, David Nash, Steve Nash, Nancy O'Boyle, Harry Parker, Renzo Piano, Ted Pillsbury, Howard Rachofsky, Carol Robbins, Deedie Rose, Nan Rosenthal, Phillip Rylands, Marcia Shields, John Stuart, Anne Tenenbaum, Calvin Tompkins, Barbara Unger, Peter Walker, Mark Wamble, and Larry Wilson.

My thanks to Winfield Padgett and Chip Chebuhar of Padgett Printing and the Summerlee Foundation, Dallas, Texas.

I was greatly helped by the insights of Owen Wilson and Larry Sisson on the manuscript.

I appreciate Mark McGarry's design of the book, DJ Stout's design of the cover, and Joe Goodwin's design insights.

The Nasher daughters, Andrea, Joanie, and Nancy and her husband David Haemisegger were forthcoming and supportive. I appreciate all the support I received from Tim Staley at the University of Texas Press.

Finally, I thank Laura for the extraordinary example she sets for me and our sons, Andrew, Owen and Luke.

EPITOME OF DESIRE

# PREFACE

THE SMALL NEIGHBORHOOD is about eight miles north of downtown Dallas and feels like country. The heavily shaded lane casually winds in an s-like way, making this an exception to the city's prevailing grid pattern. As you walk along the lane, bearing the singularly unromantic name of Miron, you suddenly come upon sculpture created by some of the great artists of the twentieth century including works by Picasso, Henry Moore, Rodin. The works are uncrowded and situated carefully on both sides of the lane. On the west side, in 2003, are late twentieth century pieces by Mark di Suvero, Tony Smith and Willem de Kooning. On the east side is an older well designed, understated modern house built in 1949, drawing no attention to itself. The house was designed by a Dallas architect, Howard Meyer, who was inspired by Frank Lloyd Wright's work.

The openness of the site is so unexpected, so democratic, especially in an era when Dallas has seen an explosion of faux mansions created by builders without the bother of architects. The canopy of trees provides cool protection on the most blistering days of the long Texas summer. This is home, both sides of the street, to one of the world's greatest private sculpture collections created by Ray Nasher and his late wife, Patsy. What's extraordinary is that there are no walls, no gates. The message from the Nashers is clear: we are not walling you out, so go ahead, see for yourself.

A sunny June afternoon in 2002. Sitting in his library, Ray Nasher, the son of a Russian immigrant, an only child, now 81, looks out across his green landscape, washed by heavier than usual spring rains. The scene closely resembles Cezanne's painting *Farm in Normandy: The Enclosure,* which hangs in London's Courtauld Institute Galleries. "I remember on the weekends when I was 7 or 8 taking the subway and trolley with my mother and father from Dorchester to the Fenway and the Boston Museum of Fine Arts. The painting I remember most from those days was van Gogh's *Postman*. It became a familiar friend on all my visits," Ray recalls. And even today when in Boston he will take the time to stop by the museum to see that painting.

Van Gogh's, *Postman Joseph Roulin*, was one of three strong, memorable portraits loaned to the Boston Museum of Fine Arts in the 1920's by Robert Treat Paine II, a lawyer and Harvard graduate,

whose family's fortune came from railroad and mining properties. The other two portraits were Degas's marriage portrait of his sister and their cousin, Edmondo and Thérèse Morbilli and Cezanne's picture of his wife in a red armchair. The portraits, later given outright to the Museum along with other masterpieces from Paine's wide ranging collection, helped fill major gaps in the Museum of Fine Arts collections. Paine's gifts to the museum were distinguished not so much by their quantity but that they be, to his mind, masterpieces of his choosing.

No one can predict precisely what will ignite a child's imagination. But that first generation American, Ray Nasher, still vividly remembers his visits to see van Gogh's *Postman* more than seventy years ago. The painting was given to the museum by a member of the Yankee aristocracy, a man of privilege who could not have been further removed from the origins of Janet and Israel Nasher and their only child.

Vincent van Gogh and his friend, Paul Gauguin, worked together in Arles the fall of 1888. Van Gogh had become, at Gauguin's urging, committed to "breaking with observation alone in favor of more reliance on memory and intuition." Ray would come to trust most his own intuition in both his business and collecting. Patsy Nasher had acute intuition herself; it would be that intuition and her drive and intelligence that would ignite and energize their early collecting efforts.

When does a collection begin? This extraordinary collection of sculpture and paintings created by Ray and his late wife, Patsy, may have begun in the early 20th century when a boy, a first generation American, saw the *Postman* in the Boston Museum of Fine Arts for the first time.

# BEGINNINGS

IMMIGRANTS TO AMERICA needed no recruiting campaigns, no persuasion to come. That they didn't know the language didn't stop them. Nor the fact that most would arrive with almost nothing. They saw an America that provided all they required—a chance. The pull of America's possibilities brought Israel Nasher to Boston in the late 1890's. He would marry a first generation American, Janet Brenner, on December 7, 1920. Almost eleven months later, October 26, 1921, their only child, Raymond Donald Nasher, was born in Boston.

This boy's Boston was obviously not the Boston of the Cabots or Lowells or Lodges. The Nashers settled in a section of Dorchester where immigrant Jews established their own close knit community; they lived in triple deckers, one family per floor. Twenty feet at the most separated one triple decker from another. Janet, Israel and their

son, Ray, lived on the third floor. Israel's younger brother lived on the second with his family, and Israel's father and mother lived on the ground level. That three decker would provide, floor by floor, the support and encouragement Ray Nasher would need. Ray says, "My parents were determined that their only child would try to be something above and beyond what their goals could be. And so they spent all their time trying to educate me."

Ray Nasher's maternal grandparents, Frank and Rebecca Brenner, had also immigrated from Germany in the late 1890's. They settled in the Bronx where Brenner opened an upholstery business. Whenever something of consequence happened in New York City, Frank Brenner would insist that his daughter, Janet, and her husband, Israel and their son and only child, Ray, come down to New York from Boston. As a result Ray Nasher, as a boy, was there, Zelig-like, for the opening of the Empire State Building and the George Washington Bridge and for the expansion celebration of the New York Public Library. Why? Because Frank Brenner, Nasher's maternal grandfather, was convinced that New York was the center of the world, and wanted his grandson to come down from Boston to see the evidence for himself. The great lesson, to go see for yourself, Ray learned for life. New York City was for him, as it has been and still is, for so many, what E. B. White described as "the white plume saying that the way is up." Many of those New York experiences often required Nasher to liter-

ally look up and see for himself where aspirations could lead—to gravity defying bridges and skyscrapers going ever higher and higher. These landmarks were created by those with an appetite for risk—the most necessary appetite for those who believe in possibilities.

Ray, an only child, was exposed to life's excitements and the arts in a way that was natural, not as a chore or duty. He was encouraged by both his parents and grandparents. He was taken to Yankee Stadium, where he saw the Murderer's Row which included Babe Ruth and Lou Gehrig. His maternal grandfather, Frank Brenner, was a strong, physical man, a marathoner, a weight lifter and a bare-knuckle boxer in clubs around New York. Those who would come to do business later with Ray Nasher would not be surprised to learn that he was descended from a man proficient in bare knuckle boxing. Nasher was being prepared to go further up the ladder his parents had begun to climb.

Ray remembers when he was eight years old the stock market crashed. In those subsequent depression years, Nasher believes the die was cast for him. Not so clearly that he knew exactly what he would do with his life but he remembers wanting to somehow control his own destiny. What that destiny would be he had no idea. He saw what the depression had done to his father; he remembers his father coming home after losing everything including two small apartment buildings he owned in Boston. One evening Israel came home and

said he had only $42.79. That's all. Ray remembers that number like the rest of us remember our first address or phone number. In 1929 the family moved to New York hoping to improve their economic situation. There Israel started a low-priced dress business with his brother-in-law, Louis Kalis. The Nashers spent 5 years in New York getting back on their feet. They moved back to Boston in 1934.

That fall Ray entered Boston Public Latin School, the nation's oldest public school, founded in 1635. Its graduates included three signers of the Declaration of Independence: Benjamin Franklin, Samuel Adams, and John Adams as well as Ralph Waldo Emerson, Leonard Bernstein and Joseph P. Kennedy. Latin School was then and is now elitist in the best sense. Anyone in the Boston city limits can be admitted who passes the rigorous entrance exam. There is no tuition. For almost four centuries Latin School has prevailed. Because it is and always has been a meritocracy. The school is true to the belief that learning isn't necessarily fun, knowing is fun. The school was and is Darwinian. At its core, Latin, Greek, English, math, history, and science still prevail. And other substantive courses. You measured up or you were out.

Even the extra curricular activities were daunting. It seems almost make believe to read in Ray's yearbook about his involvement in the Literary Club of which he was vice president. That year's program included president of the club, Franklin Flaschner, speaking on the

plays of John Galsworthy. At one meeting Ray discussed Eugene O'Neill and his writings. Norman Zatsky spoke on Maxwell Anderson at another. And Joseph McVeigh gave an analysis of Joseph Conrad. Ray was also president of the Classical Club whose sessions, the yearbook said, were "imbibed with long but highly entertaining and enlightening talks on such subjects as Latin and Greek mythology, literature and history."

Latin School was the ladder up and Ray would thrive in its competitive atmosphere. He was captain of Latin School's tennis team for three straight years and ranked among the best players in New England. He was encouraged in tennis by Helen Hotchkiss Wightman, later a member of Boston's aristocracy and one of the world's best players. She won 16 U.S. championships and would go on to create the annual Wightman Cup matches between Great Britain and the United States. She had seen Ray play in tournaments and gave him the chance to play at the Longwood Cricket Club in Brookline where she was a member; there he played on grass courts for the first time. There were certainly no grass courts in Dorchester. Even now in his 80's, he's proud to be a graduate of Boston Public Latin School.

Ray could see for himself the prejudice of Boston which worked against immigrants like his parents and against the Irish. He knew the story of a successful banker, Joseph P. Kennedy who had married the daughter of Boston mayor, John "Honey Fitz" Fitzgerald. Joe

Kennedy was an extremely successful banker and financial operator but his success meant nothing to the WASP members of the Cohasset Country Club, in a beautiful small town on the ocean 30 miles or so south of Boston where they summered. They turned down his membership application which explains why Hyannis, not Cohasset, became home to the Summer White House.

Following graduation from Latin School, Ray decided on Duke in Durham, North Carolina, an unusual choice for a Latin School graduate. It was a long way from home but Ray had always had the exceptional confidence of an only child. And you could see this clearly when he hit his stride at Duke. He was president of the student body when he was a senior. He was on the tennis team. And in 1943, his senior year, he had his own column, "Time to Think," in Duke's student newspaper, the *Duke Chronicle*. In those columns, sixty years later, a reader senses a young man comfortable with great issues, and also in the bully pulpit a column affords.

In early 1943, members of Duke's Army Enlisted Reserve Corps got the word. They would be called into the service missing their last month of their final semester and would not, therefore, receive their degrees. Ray wrote in his column, "I have been attempting to think out this problem rationally now for several months. I have tried to weigh the evidence in favor of not granting their degrees quite impartially. I readily admit that technicality that these Duke men who leave

us April 1 have not completed their total scholastic training—they will be training hard in khaki during April and a few weeks of May rather than sun-bathing on our Duke lawn. My credo is that granting these men their A.B.'s and B.S.'s will not deflate the value of their sheepskins so as to lower the intrinsic value of the college degree."

In another war time column he urges readers to do whatever they could: "We can do many tangible things while on campus to expedite our fighters' drive to Berlin and Tokyo. We can give blood at the hospital every six weeks to save the lives of our fallen heroes; we can buy war stamps at the P.O.'s to give our share toward the actual financing of our military men and equipment and to retard inflation; we can exercise daily so that our bodies will be toughened to endure actual physical combat or long hours in war industries; we can read profusely and study faithfully to educate our minds to be able to make the quick and necessary decisions which will be a part of our war job; and we can take time to think about our social, economic, and political conditions today so that we can take a certain part in the construction of the post-war world of tomorrow."

He wrote in one of his final columns, "What are we going to do about tomorrow? Today is the time to think seriously about tomorrow." Ray has never stopped thinking about tomorrow. Those columns reveal a young man who took himself seriously, in the best sense.

In 1943, after his Duke graduation, Ray immediately joined the Navy in which he would serve for four years. He did his officer's training—it sounds too good to be true—at Wellesley College. After training he was assigned to the Third Marine Air Wing at Cherry Point, North Carolina. He became an aide to Captain Russell Sullivan, Chairman of Navy Supply to the Marines. Then he was assigned to the USS *Humboldt* as a supply officer. The ship had been designated to transport all the correspondents to the invasion of Japan. The *Humboldt* was being outfitted in Philadelphia. Then, on its way to Japan, on August 6, 1945, word came that the atomic bomb had been dropped on Hiroshima. Officers and sailors, including Ray, were sent subsequently to Orange, Texas on the Sabine River to help in the decommission of ships. Ray says, "It was the first time I ever touched land in Texas."

It's no accident that Ray remembers so clearly meeting Patsy Rabinowitz for the first time in Boston at a party in November, 1948, on Election Eve. She was the only guest who predicted Truman's victory. Ray began to fall for this smart independent woman, a Dallasite and senior at Smith College in Northampton. She graduated magna cum laude in 1949, majoring in American Civilization. They fell in love that winter. In the aftermath of the war, courtships tended to be brief. Ray and Patsy were no exception. They were married July 25, 1949 in Dallas. Patsy, her collecting instinct apparent early, would save

the 72 telegrams of wedding congratulations she received; the following year, Ray finished work on his Masters Degree in economics at Boston University. Then they returned to Dallas.

Patsy's family was well to do but not at the level of the Texas Super Rich. Ray worked for Patsy's father but it didn't last long. He rented a small windowless office in downtown Dallas and there began his life as an entrepreneur. He began by learning the residential development business. He built houses for returning veterans in the Oak Cliff section of Dallas, a decidedly across the tracks location. The houses were sold for $8,000 to $10,000. No down payments were required. The twenty year loans with monthly payments of $30 to $34 were appealing to veterans. His success was solid but not spectacular. Dr. Donald Seldin, a brilliant doctor, who would become one of the architects of Southwestern Medical School's greatness, knew Nasher slightly in these early years; Dr. Seldin was treating Meyer Rabinowitz, Patsy's father, who was very ill at the time. Dr. Seldin and his wife Muriel had a party to help introduce the Nashers to their friends. He took one of the guests aside and told them, "Keep your eye on this man. He's going to be a millionaire." That's when being a millionaire meant something. Ray's drive and intelligence and his competitive instincts (seen most clearly on the tennis court) were apparent.

He kept in the back of his mind something his father had said. Ray's father was bright, driven, and realistic. He told Ray, "You can't

be President of the United States because you're Jewish. But there are two things I hope you'll do in your lifetime: own a baseball team because I love baseball. And own a bank because that's where the money comes from." Israel Nasher's two wishes would come true. Ray became an owner of the Texas Rangers (along with the future President, George W. Bush). And Nasher has been chairman of a bank since 1965.

Ray went on to create some middle class housing developments in the more affluent fast growing North Dallas area. But he was looking for bigger things and abhorred, he remembers, the idea of having his life on any sort of autopilot. Ray and one of the men who worked for him at the time had made contact with people in Tulsa, Oklahoma. They went up to visit and while there met with the vice president of one of Tulsa's prominent banks. He told Ray about a piece of land on the Arkansas River that was owned by some leading Tulsa citizens. He asked whether Ray would be interested in developing the land. By nature, Ray was always interested but could take a long time to commit. He has always liked keeping all his options for as long as possible.

When he decided to go forward, he brought in E. G. Hamilton, an imaginative and confident young architect from Dallas, to work with him on the Tulsa project. Next he involved the Dallas builder, Centex, as a partner. Together they designed and built a 17-story

apartment building for the carriage trade. The building was well received and is still considered one of the best addresses in Tulsa: 2300 Riverside Drive (it's endemic with developers to borrow names with successful connotations). Riverside Drive became a design award winner, Ray's first award. This was more like it in terms of what Ray wanted to be known for: the marriage of notable design, association with top creative people, and upscale real estate projects.

# NORTHPARK

WEALTH FROM A VARIETY of directions animates great collectors and their collections. New money. Old money. The self made and inheritors. The munificence of Walter Annenberg's collection and his great gifts to the Metropolitan Museum in New York derived from his father's creation of the *Daily Racing Form*. The son founded *TV Guide* in 1953. *TV Guide* became a huge money maker as television took over the nation; in the late '70s the paid circulation had grown to 20 million copies per week. In 1988 Annenberg sold *TV Guide* for $3 billion. In 1991 Annenberg gave New York's Metropolitan Museum his collection, valued then at more than a billion dollars. Annenberg was the friend of presidents and served as the Ambassador to the Court of St. James. He had proved himself as a young man after his father was jailed for tax evasion.

Joseph Hirshhorn's fortune was driven by "the bitter taste of poverty." One of thirteen children who emigrated from Latvia to Canada with their widowed mother, Hirshhorn would spend his life trying to erase that taste. He would make his money in minerals in northern Canada coming to be known as the "Uranium King." Hirshhorn built an extraordinary collection, using his own wits and keeping his own counsel. He said, "I don't ask the advice of anybody." And he also said, "I'm not an investor, I'm a speculator." Hirshhorn would later meet his match for dealing in President Lyndon Johnson. Johnson's vaunted treatment and persuasion resulted in Hirshhorn's great gift of his collection not to his nation but to our nation; the Hirshhorn Museum and Sculpture Garden has an address on the Mall in Washington, D.C.

Then there are the collections of those born to extraordinary inherited wealth. The Rockefellers epitomize this group for their generosity and thoughtfulness, one generation after another. They knew what they were doing with the immense amounts of money they gave and the investments they made. Rockefeller Center. Rockefeller University. MOMA. They also gave their time and insights to the institutions they so generously served.

So where did the money come from that enabled the Nashers to create a sculpture collection of such depth and renown? The answer can be found in Dallas at the northwest corner of Northwest High-

way and Central Expressway; on these 95 acres Nasher built North-Park, a mall of architectural distinction that has produced exceptional financial results for more than four decades. When NorthPark was completed in August, 1965, it was the world's largest climate controlled mall. Not even the Nashers could have predicted the scale of NorthPark's success.

In the early sixties, shopping centers were generally uninspired from an architectural standpoint, attracting neither the most enlightened real estate developers nor, therefore, the best architects. NorthPark, however, would provide a powerhouse of an exception and go on to win the Design of the Decade award from the AIA. And just as important to Nasher, NorthPark would enjoy the highest sales per square foot of any major suburban shopping center in the nation. Ray believed that financial performance could be enhanced by exceptional architecture. And NorthPark's performance provided all the necessary evidence.

One of the strongest architectural influences on NorthPark was E. G. Hamilton, a young architect who had worked with Nasher in the past.

Hamilton recalls that at the time, most of the shopping centers were "chaotic and lacked a unity of concept." There was no question in his mind that Ray wanted something different.

"People don't recognize the fact that NorthPark, for all its acclaim, had a very tight budget. It was not at all a luxury project," Hamilton

said. The mall floors were polished concrete. Some of the stores, Neiman Marcus certainly, may have been luxurious but the project wasn't. Hamilton believes that a tight budget isn't always a detriment. The budget notwithstanding, the Nashers wanted NorthPark to be both notable and distinctive.

The unifying intention for NorthPark was to create a space that made people comfortable. Hamilton said they designed portals between spaces that made the mall more intimate as people moved from one section to another.

History shows Ray will fight because he believes so strongly he's right. Ray won a key early battle over aesthetics with NorthPark's retailers. They wanted to design their own entrances from the mall into their stores. Ray wanted the entrances for all the stores to be unified using NorthPark's signature white brick. That again made it easier on the eye, less chaotic. The white brick entrances still prevail. The decision on the white brick was made by the Nashers because white was used in many of history's greatest buildings including the Parthenon. Ray enjoys having NorthPark in the same company as the Parthenon.

As difficult as Ray can be sometimes in making up his mind, his way works. To do a few things extraordinarily well describes the arc of his career. Hamilton believes Dallas doesn't have as much exceptional architecture as it should, because it takes good clients to get great

architecture. For instance, in Hamilton's opinion Dallas and Fort Worth have gotten the late Philip Johnson's lesser work—the Amon Carter Museum for example—because the clients didn't understand how to get the best from the best architects. But Ray had a sense of how to get an architect's best work, and the longevity of NorthPark is the evidence. He did it with great restraint and discretion. When NorthPark was created, it was the nation's largest commercial facility of its kind without any signs saying what it was. And it remains so. Ray wanted NorthPark's architecture and color to be its sign, its only sign.

Another associate of Ray's early on at NorthPark, Joe Barta, said the greatest mistake you could make with Nasher was to focus only on staying within budget. Nasher wanted only the best and left it up to his team to figure out how to get it. "We had to figure what trade offs to make to sustain NorthPark's perception as the best of its kind," Barta says. He also emphasizes how closely Patsy and Ray worked together on NorthPark. Her opinions had real influence on Nasher's thinking. She was from the outset an enthusiastic advocate for the sculpture in the mall. Nancy Nasher strongly believes NorthPark succeeded because, "it was truly a partnership in every sense of the word between my mother and father. I don't think there was a design decision my father didn't run by her."

Ray's approach required that his team take initiative instead of simply taking orders. The idea was to just do it. Whatever made the

most sense, whatever contributed to NorthPark's mystique, whatever would enable NorthPark to create more customer traffic which would lead to more purchasing and higher revenues for NorthPark, Ray wanted. Both Patsy and Ray Nasher believed in the transforming impact of the right ideas. With NorthPark they broke rank with all the pedestrian thinking that had characterized malls. One of life's continuing mysteries is how little impact good ideas have in certain sectors. NorthPark's style, for example, has seldom been duplicated.

One of the keys to NorthPark's supremacy was Stanley Marcus's reluctant decision to make Neiman Marcus NorthPark's high end anchor store. In the early sixties, Neiman's had only one store besides its downtown location, a successful suburban store nine miles north of downtown in the Preston Shopping Center on Northwest Highway. Marcus had no interest when Nasher first approached him with his plans for NorthPark and why it would make sense for Neiman's to move there. Marcus wanted instead to expand the Preston store. Against all odds, Stanley had built Neiman Marcus, a store Stanley's father, Herbert Marcus, Herbert's sister Carrie Marcus Neiman and her husband, Al Neiman founded, into a beacon of style and panache unequalled by almost any other American retailer. And he did it in Dallas, a long way from New York and Fifth Avenue. Stanley did not envision Neiman's customers wanting to mix with the customers that more plebian retailers would attract to NorthPark. Ray had no

backup, no other retailer of such repute to fall back on if Neiman's decided against having a NorthPark store. NorthPark could go forward but the ceiling of its possibilities, Ray knew, would be diminished. While NorthPark could succeed without Neiman's, Ray knew it could not approach the level of financial success or, just as important, become an immediately recognizable address of true distinction in retailing. For this reason, Stanley and Neiman Marcus were not on Ray's wish list; they were on his must have list. Neiman's style and history would validate all that he wanted NorthPark to stand for.

Stanley Marcus's imagination and flair left him with little interest in conventional wisdom. He never considered himself or Neiman's to be one of the pack. This explains his initial lack of interest in NorthPark and the other retailers who would be his neighbors. After all, how could they help him? This was the hurdle Ray faced in getting Stanley to commit.

As their conversations proceeded, Ray told Stanley he didn't think Neiman's could get the neighbors in the University Park residential area to approve Neiman's planned expansion of the Preston Center store. The increase in traffic and congestion from Neiman's would trigger strong neighborhood opposition. When Stanley and his team did their homework, they found Ray was right. Stanley, as a result, finally decided Neiman's would go to NorthPark and a much larger store with plenty of parking. Neiman's would not absolutely guarantee North-

Park's success but it was the next best thing. Even after his decision, Stanley, a liberal Democrat and elitist in the best sense, still believed his customers would not enter Neiman's from NorthPark's mall; he foresaw them coming directly into Neiman's through the store's entrance on the west, thus avoiding the mall. He thought his customers would do their shopping at Neiman's and then go home, ignoring less sophisticated shoppers and the stores they favored. Stanley would in fact oversee the creation of a grand entrance designed with fountains and reflecting pools on either side. He hired Eero Saarinen who had created the Gateway Arch in St. Louis and the TWA Terminal at JFK Airport as his architect for the NorthPark store. The entrance to Neiman's from the mall, accordingly, was modest and unprepossessing; it seemed like an afterthought, a true back door. Stanley, who was always prescient about retailing and so many other things, missed on this one. And today that entrance from the mall into Neiman's cosmetic section provides significant traffic to the store.

With Neiman's, Ray had the anchor of elegance he believed NorthPark needed. NorthPark would become Neiman's most successful store and still is today; the center's other large, more moderate retailers would be helped by Neiman's presence. And Neiman's, Stanley's view notwithstanding, would be helped by their traffic as well. Perhaps the final evidence of NorthPark's attraction to the nation's ultra stores was the decision by Tiffany's to locate directly across from

Neiman's "back door" in May, 1999. Neiman's and Tiffany's North-Park stores have done nothing but strengthen their positions among the country's most profitable high end retailers.

There was a natural, unstated competition between Stanley and Ray. Stanley, after all, was a national, even in some ways, an international figure. He sought the spotlight for the Store, the shorthand phrase for Neiman Marcus, and himself. He made Neiman's Christmas Catalog an event. He understood the cult of personality before there was such a phrase. Ray and Patsy, on the other hand, had not yet experienced the big roar fame can generate. Now Stanley and his reputation would help create the Nashers' reputation and the mystique for their shopping mall. NorthPark's Neiman's is the most successful of the 35 Neiman Marcus stores.

NorthPark also provided large interior spaces with natural light which Patsy and Ray Nasher believed could be energized by the placement of sculpture, especially larger pieces. Patsy foresaw that North-Park could benefit from their collecting, whether it would be Warhols or Miro scarves or the sculpture or the great Frank Stella which hangs in NorthPark's interior. She became close friends in the late '60s with the sculptress Beverly Pepper. The Nashers commissioned her to do a major outdoor sculpture. She created a 236-foot-long Cor-Ten steel earthwork titled *Dallas Land Canal*. Pepper lived with the Nashers for months during the creation of the sculpture for NorthPark's exterior

which was perfectly suited to the imposing presence of the large piece. Now in her 80's, she remembers, "We were all neophytes as far as the project was concerned." Patsy and Ray took chances. Today, there's probably no space on the planet that comes close to exposing more people to sculpture than NorthPark—22,000,000 visitors a year. That was a benefit of the law of unintended consequences.

The Nashers paid close attention to NorthPark's landscaping. Lawrence Halprin worked with them as he would years later on the Nasher Sculpture Center. There is a definite restraint to the landscaping plan he created with the Nashers' close involvement. And that landscaping along with NorthPark's design have changed little over the decades. The large planters they created seem to grow up naturally from the floor. Little kids slide today on the sides of those dark brick planters just as their parents did when NorthPark opened. The planters weren't designed for that; it was the children who discovered the slide possibilities. Natural light enahnces the NorthPark experience with skylights and clerestory windows; they help contribute to the feeling of comfort and well being.

It's a small but significant detail that all NorthPark's flowers and other plantings are real and it's been that way since NorthPark opened. Patsy, whose gardening instincts had been honed landscaping the grounds of the house on Miron, insisted. Halprin, of course, supported Patsy's requirement.

Ray would try to continue NorthPark's success, just east, across Central Expressway on land he controlled. NorthPark East was just a few hundred yards from NorthPark but just far enough to not succeed. Not even Nasher's success and reputation could stand up against the immutable first commandment of real estate—location, location, location. Movie theaters, restaurants, office buildings would be built by Ray in NorthPark East. They tied architecturally; the same white brick was used. But when people don't want to come, nothing can stop them. The movie theaters in NorthPark East are closed now as are the restaurants.

NorthPark's great movie theater adjoining the shopping center has also closed. Its two large-screen theaters had been the best place in town to watch movies. Moviegoers and their parking demands diminished parking needed for shoppers. The math was simple: Tie up the parking space for 2 ½ hours or so with people buying popcorn and a movie ticket, or make the parking space available to shoppers spending $50, $75, $100, or more in the same amount of time in NorthPark. Success ended the thirty-three-year run of NorthPark's theaters. But now there are ambitious plans to bring movies back to NorthPark. North-Park continues to reinvigorate and reinvent itself under the leadership of Nancy Nasher and David Haemisegger, her husband. And still attracts many of the nation's greatest retailers. Ray himself still checks the sales every day and remains involved with planning and financing.

# WATERSHEDS

Watersheds are sometimes only evident in hindsight. Ray recalls the first work of art he and Patsy bought in 1951, a Ben Shahn gouache of four tennis players. They bought it on a whim at Edith Halpert's Downtown Gallery in New York City probably because Ray was such a devoted tennis player. This, the Nashers believed in retrospect, marked the beginning of their collecting. The Downtown Gallery was founded in 1926 by Edith Halpert whom Aline Saarinen described as having "impudent and fighting faith in American art." She was just the kind of woman the Nashers would like—knowledgeable and opinionated, a woman who fought for the artists she represented. Later, in retrospect, both Nashers viewed the Ben Shahn gouache as a watershed in their lives as collectors.

In 1978, Bill Jordan was both director of the Meadows Museum at

Southern Methodist University and chairman of the school's art department. He had received his Ph.D. from NYU's Institute of Fine Art at twenty-seven. SMU hired him immediately. He had both the eye and the prescience to recognize artists and collectors early. He was and remains self-assured but not self-important. Jordan knew both Patsy's and Ray's interests and was aware of what they had collected. There was something, he remembers, about the intensity of their interest and appreciation for sculpture he found unusual. Jordan was impressed by Patsy's focus and research and a kind of fearlessness. She knew how to dig in and do the research. She created relationships with dealers and curators. This was something she was clearly doing for herself and her husband, not for acceptance by Dallas's high society.

In 1978, Jordan met with the Nashers and suggested that he do a show at the Meadows based on what they had collected. Patsy said, "I'm not sure you want to do that, Bill. Your job could be put in jeopardy if you show what we have. Because we don't know that we have a collection." Bill replied simply, "Let me worry about that." So with that, the Nashers said, "Fine. Go ahead."

Before the SMU show, what the Nashers had, Bill Jordan observes, was a collection of collections. The SMU show would suggest to them the level of meaning collecting could have in their lives. In the aftermath of that small show—there were only 24 pieces in that show—their commitment to collecting accelerated. From the momentum

generated by that modest show at SMU, collecting would become, in the next decade, the seminal activity of their lives.

While some observers of the Nashers' development as collectors believe the Nashers place too much significance on the SMU show in 1978, Ray Nasher disagrees. "Our confidence was strengthened," Ray recalls. "Our belief in ourselves was strengthened. Patsy could now see that her instincts were right. Seeing what we had in that small show was a stimulus to keep going and step up the pace." Patsy would later say about her collecting, "The work acquired me. I didn't acquire the work."

What Jordan wrote in the modest catalog for the show still rings true today: "Every collection reflects the spirit and the taste of its collector, and, had objects by even the same artists been put together differently, the sense of the whole might have been lackluster and merely academic. A search for quality and the true joy of collecting are the motivating factors behind the formation of this growing and coherent collection."

Ray remains more than ever in the hunt, driven by the joy collecting brings him. While the collection has more than 300 pieces, it is the coherence of the collection and the caliber of the acquisitions that have created the Nashers' stature as collectors.

"Patsy," Jordan emphasizes, "was certainly to my mind the prime mover in the beginning. They were both aware early of the possibilities of being taken advantage of so they moved slowly in the early

stages." Jordan went on, "Nevertheless, I believed they just had it within them. They were open to learn and had excellent instincts." Jordan remembers when he would compliment Patsy in those days on the collection's momentum, she would reply, "Well, if you think this is great, just wait till Ray catches fire because he's got the real money."

Another turning point for them was the purchase of the Morris Louis painting in the dining room. It had been offered to them before but the price seemed high. Shaindy Fenton, a Fort Worth art dealer, offered it to them at a much lower price. They bought it and the transaction contributed to the trust Patsy, especially, would come to have for Shaindy. Shaindy, who died at 42, created in the art world a dramatic persona for herself that was over the top. Big Texas hair, the reddest lipstick, diamonds as big as the Ritz, and rubies, satin suits, and a flashy Mercedes when there weren't many around. She chose not to blend in. She was, as one insightful observer said, flamboyant, but generous and honest and admired and trusted by New York's best art dealers including Leo Castelli. She helped and encouraged the Nashers. She convinced them to go right to the top wherever possible; she shared her knowledge on how to buy and negotiate. These instincts Ray had certainly developed in real estate but the art collecting world had its own history, nuances, codes and pretensions which had to be understood. She encouraged the Nashers to always end run the middleman and go right to the artists or certainly their main deal-

ers. Patsy started aggressively collecting the prints of Andy Warhol and Jasper Johns. The extensive holdings she had in the prints began to serve as her currency.

Patsy was affected by the changes in the late '60s affecting so many young women. Women in their 20's and 30's were beginning to break loose from traditional roles. *Ms. Magazine* created by Pat Carbine and Gloria Steinem had considerable impact. One of the messages of those times—don't be a male junkie—was irreverent but somewhat destabilizing especially to older women who had rarely been encouraged to pursue their own destiny beyond being the good spouse. Now in her early forties Patsy, one daughter said, was driven and striving at a time when women had not yet arrived.

Patsy's friend, Nancy O'Boyle, remembers Patsy saying once, "Weren't we lucky to have gone to Smith?" O'Boyle believes that caliber of education prepared Patsy to do the research necessary to acquire works of art, to track the provenance, to put the work in perspective. She had significant influence on Ray's thinking about NorthPark and encouraged his unconventional thinking about what a shopping center should be. Both Nashers saw that their sculpture could help define NorthPark. Patsy was becoming more and more absorbed and energized by her collecting.

Ray was consumed by the business in those days. Patsy was taking the lead in collecting but Ray by now was clearly infected with the

impulse to buy. Neither knew for sure where things were headed. Ray was preoccupied with NorthPark and other development possibilities in Florida; he was not ready yet to consider the big price tags.

The Nashers liked to learn for themselves; they began to find they had the instincts and savvy necessary to play the collecting game perhaps at the highest level. One story underscores their boldness when it came to getting what they wanted. It was the Voltri VI sculpture by David Smith they bought from Nelson Rockefeller. The piece was considered one of Smith's best works. Ray and Patsy did not let the prominence and reputation of the Rockefeller family stand in the way of the expanding ambition they had for their own collection. They dealt directly with Rockefeller himself.

The Nashers bought *The Kiss* by Constantin Brancusi in the seventies and it became one of their favorite pieces, sitting then and now at the center of their dining room table.

Steve Nash, the director of the Nasher Sculpture Center remembers Patsy "as just the most passionate, adamant, devoted, voracious, knowledgeable collector I had ever been around." She was "indomitable when it came to tracking things down and staying in touch with the markets." They were a great team with a balance good teams always have. Ray was more deliberate, Patsy more instinctive. Ray was more interested in how something would fit in historically with the rest of the collection. Patsy was more interested in younger less established artists.

Patsy loved Basquiat; Ray's enthusiasm for his work was restrained at best. They nevertheless bought a number of his paintings which explain Ray's oft quoted explanation of how he and Patsy made acquisition decisions together: If they saw something he liked that she didn't like, they would go away and think about it. If they saw something that she liked and he didn't, then they'd buy it.

"A real collector must have a sense of abandon, knowing that you cannot help yourself in the face of an opportunity to possess something of significance," said Deedie Rose, a thoughtful collector herself who has followed the Nashers' ascent. "Patsy knew when she saw something she had to have," she added. Ray's passion, in the beginning at least, was not as great as his wife's; he had to focus on North-Park and various other real estate possibilities. However, when Patsy died, Ray became the prime mover. What she had been, he became. What they had begun together, Nasher would now accelerate. Her passion kept alive in him.

What describes the Nashers' collecting before the lift-off and world acclaim was a phrase used to describe one of the nation's great benefactors and collectors, Paul Mellon: "the authenticity of his affections." Harry Parker, who became friends with the Nashers when he was director of the Dallas Museum from 1974 to 1988, (he's now the director of the San Francisco Museum of Fine Arts), has followed the arc of their collection for more than a quarter of a century and says

simply the Nashers were in that small minority who truly loved what they acquired.

The Nashers' middle daughter, Joanie, remembers growing up thinking of the art as siblings. "It was kind of fantasy and whimsical. I can remember doing my homework leaning on a Henry Moore. We were encouraged by our parents to touch the sculpture. It was not something off limits. We were given the chance to experience the art in the most natural way. Certain artists would live with us for a while and do their work. We had white carpets in the house and I can remember the futile mantra, "Don't spill anything on the carpet."

Both Patsy and Ray were focused on individual acquisitions. There was no great master plan. Nancy O'Boyle, said, "Patsy knew you had to work to know. She didn't believe true collecting could be farmed out. Before it became "The Nasher Collection" it was one piece at a time bought for its particular pleasure. Patsy and Ray were a real partnership but he had to depend on her for the research and homework especially in the early stages. He always respected her judgment."

Joanie remembers how much Patsy and Ray loved going to visit the studios of artists in whom they were interested. The photographs of the two of them with Henry Moore in his studio in Much Haden, England, in 1967 are portraits of a couple concentrating with an unmistakable, thoughtful respect for the artist. It's a portrait of a couple absorbed in learning. There's nothing casual in their expressions

Sometimes just Patsy and Joanie would travel. Patsy loved the freedom travel afforded. She would do all the homework, Joanie recalls, what landmarks, galleries and museums to see, the best restaurants to go to. "My mother loved the adventure of collecting. The beginning recognition of the collection surprised her. While she cared what people thought, she strongly believed she and Dad collected for themselves, not for any seal of approval from the art world. In spite of the publicity, we were a private family." Joanie is clear about what she received: "I learned from my mother the importance of having an eye and doing the work necessary to have an understanding receptive eye. I learned from them about the joy collecting could bring. And the necessity of constant research and the study. We were five independent people in our family. I learned from my mother how to live with myself and my interests."

# LIFT-OFF

One prominent collector said those collectors who stay the course generally go through three stages.

The first is characterized by insecurity about what to buy, what to pay, worry about what the gossipy, sometimes back-stabbing art world thinks of them and their decisions. Dealers understand the pathology of the beginners. They present themselves to collectors as trusted scouts who go out ahead of the settlers and their wagon train to prepare them for whatever opportunities and dangers lie ahead. Beginner collectors face at times hostile territory. They can be taken to the cleaners or even worse, made to look foolish. The most honorable dealers, those who sustain the longest relationships, look for a route that will protect new, and perhaps, naïve collectors.

The second stage is marked by the creation of the collector's con-

fidence derived from recognition bestowed by the art world—esteemed collectors, museum directors and their boards, dealers and the media.

The third stage reflects the collectors' refining of their collections. Their willingness to do whatever's necessary to fill in gaps and to make dramatic acquisitions necessary to strengthen the collection's breadth and depth. That is to say, for the true collector, there is no coasting in this stage. The best way to protect a lead, whatever the endeavor, is to increase your lead, not sit on it. The third stage can be the true tipping point leading to membership in that small club reserved for those collectors whose collections are among the best that imagination and insight, taste and money can create.

In collecting, many things need to be learned—art history, provenance, reputations of dealers and curators, the tactics of other collectors. What can't be learned are instincts to make the right moves in the face of incomplete information. Instincts can make possible successful leaps of faith. As William James said, ". . . the art of being wise is the art of knowing what to overlook."

It takes time in any endeavor to decide what way to go makes the most sense. For the most savvy collectors it involves breaking through successive ceilings to more and more significant acquisitions. The breakthroughs come with the development of taste, the acceleration of passion and, of course, the necessary means. And nerve.

By the early eighties the Nasher daughters had grown up. The writer Elizabeth Frank wrote about Patsy, ". . . once her children had grown and she began to collect art in earnest, she did so with the ardor of someone whose hitherto suppressed or deferred talents have been released with overwhelming urgency and with the deep pleasure that comes from having earned the right, after years of dedication to others, of doing something that offers supreme rewards to oneself alone. She discovered she was a born collector—a natural."

The most significant exhibition in the Nashers' collecting lives was proposed by Harry Parker, the director of the Dallas Museum of Art, and Steve Nash, its chief curator in the mid-eighties. They were both close to the Nashers and had some reason to hope that perhaps the Nasher family would give their collection to the DMA. Parker and Nash envisioned a Nasher exhibition that would open in Dallas and then travel to other venues in both Europe and the United States. All the stops would be taken out to make it one of the greatest shows in the history of the Dallas Museum of Art.

J. Carter Brown, the resourceful and entrepreneurial head of the National Gallery had met Ray and knew of the quality of the collection he and Patsy were creating. In fact he and Nasher had met and had casual talks in the early eighties, about the possibility of a Nasher show at the National Gallery. Ray began to loan certain pieces from the collection to Brown. One evening in 1985, the new curator of

twentieth century art at the National Gallery, Nan Rosenthal, was working late. Everyone had gone; the phone rang and it was Carter Brown. He said, "I can't remember the name of that fabulous sculpture collector couple from Dallas. Do you know them?" The new curator, Nan Rosenthal, now Senior Consultant of the Department of Modern Art at the Metropolitan, said she didn't know but she would find out. She did and called Carter Brown back in a few minutes with Ray's number. Brown said he would call Ray and suggest to him that Nan Rosenthal go to Dallas with her colleagues, Gaillard Ravenel and Mark Leithauser. Ravenel and Leithauser were highly respected for their imaginative installation of the National Gallery's exhibitions.

It's all in the chemistry. In a few weeks, Rosenthal, Ravenel, and Leithauser flew to Dallas to begin exploratory talks about a Nasher exhibition at the National Gallery. They arrived in time for dinner at the Nashers'. Ruby Hairston, who had worked for the Nashers for years, served her famous fried catfish. The dinner was down home all the way. "What I liked," Rosenthal recalls, "was the Nashers' complete lack of pretension and the way their remarkable sculpture collection was situated on the beautiful tree covered grounds. Everything was well thought out but there was nothing fussy or pretentious about how the art was displayed."

The next day the Nashers, Nan Rosenthal, Ravenel and Leithauser all got down to business. What pieces did Rosenthal want?

What were the Nashers willing to part with for the exhibition? What kind of sculpture bases should be used? There was a clear spirit of cooperation. Rosenthal remembers being so impressed by Patsy. She reflected the style of their house—straightforward, no airs or self importance. Patsy, she noticed, was not at all hesitant about asking questions whose answers could deepen her own knowledge. "It was so impressive to see how hard she worked to teach herself more and more in spite of her illness," Rosenthal remembers. It was clear to Rosenthal that the Nashers were a team and that they were ready, as collectors, for the world stage.

There was a slight hitch with the National Gallery when Carter Brown said the National Gallery had a policy requiring that shows of the magnitude of the Nasher Collection had to open first at the National Gallery. Ray politely explained that the Nasher show would open at the Dallas Museum of Art. Dallas, after all, was home to the Nashers and Dallas was where their collecting lives had begun and where they had made the money that made the collection possible. And further, the idea for the Nasher exhibition came from Henry Parker and Steve Nash. Carter Brown took the news to his trustees and they made an exception. The Nasher Exhibition would go to Washington after the show in Dallas.

More than forty years ago, just as the Nashers began to collect in tentative ways, we heard, through the static, words broadcast from

Cape Canaveral, "We have lift-off," a phrase connoting the beginning of our nation's new ambition, to go to the moon and beyond. Lift-off is evocative of and applicable to so many other human endeavors: a writer's first book, a director's first movie, an entrepreneur's first venture. In the mid-eighties the lift-off of the Nasher collection served notice to the world of their collection's caliber, and the rocket of their own ambition. The world would now see for itself what the Nashers had achieved. From Dallas to Washington's National Gallery. Then on to Madrid. And Florence. And Tel Aviv. There was no way to tell how triumphant in every way the collection's lift-off would be.

Steve Nash, who was at the time a curator at the Dallas Museum of Art, played a pivotal role in the organization of the 1987 Nasher exhibition and also wrote the scholarly and insightful catalog. When asked what he considered to be the true watershed of the Nashers as collectors, he responded emphatically, "In terms of collecting drive, I would say the Nashers' acquisitions in the mid-eighties leading to the American and European tour represented a true watershed." Those acquisitions would lead to the birth of far flung respect for the collection worldwide. The tour also marked the beginning of their recognition not only as insightful collectors but also sponsors of serious scholarship.

"In terms of collection growth," Nash continued, "whether out of sheer momentum or momentum energized by realization of the

forthcoming exhibition and the attention it would create, the period of 1986–87 has to be considered one of the high water marks, if not *the* high water mark, for both the number of acquisitions and their significance. Just to recap a few of the highlights, in that span the Nashers added: Brancusi's *The Kiss*, two major Caro pieces, five works by Duchamp-Villon, the great Gauguin *Tahitian Girl*, the Giacometti *No More Play*, Lachaise's *Elevation*, Matisse masterpieces *tiari* and *Reclining Nude—Aurora*, three great works by Picasso, the Puni *Construction Relief*, two Rossos, the Segal *Rush Hour*, the Serra *My Curves are Not Mad*, three works by Joel Shapiro, and three works by David Smith. And there were others. This would be an amazing treasure trove for any museum, and is almost unheard of for a private collector. There is little doubt in my mind that the reality of the approaching exhibition added fervor to their collecting drive."

The caliber and number of acquisitions in this period were and remain the apogee of the Nashers' collecting. So far.

For sculpture collectors who knew what they were doing, which the Nashers clearly did, the mid-eighties were truly exciting years. Modern sculpture prices then still lagged considerably behind prices of comparable quality paintings. The Nashers recognized the value gap in sculpture pricing and took advantage of the possibilities to strengthen their collection.

John Walker, former director of the National Gallery of Art, once

wrote, not critically, but as a matter of fact, about Ailsa Mellon, who donated significant collections to the National Gallery, and the critic and collector, Bernard Berenson, ". . . both bought works of art only for the use and decoration of their houses. Neither had that irresistible desire for acquisitions for their own sake which makes a true collector." The Nashers had that desire and as the future would show, their desire would not diminish.

Both Patsy and Ray led lives beyond the narrow confines of business. They pursued other interests in the environment, politics and government. You could see the evidence in the causes they backed and friendships they made with artists and journalists and political leaders. Ray and Patsy were loyal Democrats and strong supporters of President Johnson. The Nashers, however, were not what were called in Texas "Yellow Dog Democrats"—Democrats who would vote for a yellow dog before they'd vote for a Republican. Ray admired LBJ's extraordinary energy, political savvy and the scope of his Great Society initiatives and was appointed by the President to serve as United States Delegate to the General Assembly of the United Nations in 1967–1968.

Ray and Patsy spent two years at Harvard. Ray taught Urban Economics at the Harvard Graduate School of Education. There they lived on Brattle Street, one of the most beautiful American streets and were stimulated by their Cambridge-Harvard experience.

Beginning in 1976, the Nashers summered in Wellfleet near

Provincetown on Cape Cod; their house was a short walk to the National Seashore. It was the same year Patsy discovered she had breast cancer which was treated at the Beth Israel Hospital in Boston. The treatment seemed to work. But eight summers later, in August 1984, when Patsy returned to Dallas from Wellfleet, she couldn't get out of bed; she could hardly move. It was the first time Nancy ever remembered seeing her mother immobilized. At first, the doctors thought it was Lyme Disease. Within a month her vision was affected. That's when an MRI showed a tumor behind her eyes that was pressing on her optic nerve. Patsy then went to New York for brain surgery. Nancy remembers, "Everything stopped for us as a family. It was terrible. She was absolutely courageous. She showed no self pity." That's when the collecting became more aggressive than it had ever been. The collecting was the only thing that gave her pleasure and solace. Following the collection's tour beyond Dallas gave Patsy a focus and she willed herself to go. Following the success of the Nasher Exhibition in Dallas, the show moved, as agreed, to the National Gallery. There she would see for herself the immense banner on the National Gallery proclaiming the Nasher Collection opening in June, 1987.

The significance of the Nasher's exhibition at the National Gallery Show in June of 1987 cannot be overestimated. The nation's cultural and power elite now saw for themselves what the Nashers,

these two outsiders, active Democrats both, had achieved through their determination and focus. And then, if the elite required additional imprimaturs they could read the rave reviews in the two newspapers the nation's capital depended on most to keep score, the *Washington Post* and the *New York Times*.

Imagine the Nashers waking up in their Georgetown hotel June 28, 1987, the morning after the opening of their exhibition and reading the lead sentence of the Post's review, "In the near-decade of its existence, the atrium of I.M. Pei's National Gallery East Building has proven to be an altogether splendid space, but never has it looked so appealing as today. . ." Or later in the review: "The Nasher Collection is full of provocative riches; it is worth many visits for itself and the way it brings Pei's spaces into crisp new focus." Imagine the Nashers' pleasure. Patsy Nasher, who was now close to the end of her life after her long, debilitating illness was still able to fully sense the import of the occasion. She told her friend, the insightful novelist Kate Lehrer, after the triumph at the National Gallery, "Nothing matters now."

Patsy understood what she had achieved. The contagion of her passion drew her husband to collecting. What they would collect together, their own study and scholarship, their trust in each other's judgment would define their lives as nothing else would. Both Ray and Patsy recognized clearly that she had been the prime mover of their collecting in the beginning. She had ignited in Ray the

excitement that collecting only the best can trigger. Her collecting fervor, beginning with Pre- Colombian and then textiles and then on to sculpture and major paintings, had led them to be sanctioned by a world tour which went through Dallas, their adopted city, and then to their nation's capital and then onward to Europe. Homage was paid to their collection and them.

A few years before the exhibition, Carter Brown, who understood all the subtleties of ego suasions necessary to reel in great collectors and their collections said, "What I admire about the Nashers is their accelerating enthusiasm and their assiduousness." With this seminal exhibition of their collecting prowess, the evidence of that enthusiasm and assiduousness and collecting prowess spoke for itself.

The National Gallery show was the greatest launch of a collection, from every perspective, the Nashers could ever imagine. Washington was the capital of the free world and the National Gallery was just a few hundred yards south of the Capitol Building. The architect of the National Gallery's East Wing, I.M. Pei, was one of the most influential and respected architects of our time; his reputation was still on the ascent with several great buildings ahead including Dallas' Meyerson Symphony Hall. What did he say to Ray Nasher in the National Gallery as they both watched from above as the visitors moved through the charged atmosphere of the collection's opening? "This is why I designed this building." This was the Nashers' moment.

Ted Pillsbury who was director of the Kimbell Art Museum in the '80s remembers a lunch with the Nashers. At the time a dealer in New York had a major Matisse bronze priced at over $1 million. Both Ray and Patsy really wanted it. But they couldn't quite understand why it was so expensive. Pillsbury said, "We talked about getting the best because only the best stands the chance of surviving the vicissitudes of history and changes of opinions." The Nashers were willing to pay the initiation fees—the high prices the best work can command—in order to enter that small company that wants only the best. Nasher began to see that it wasn't the price of the sculpture so much but another way to reallocate their resources. They also discussed the best dealers and the role they could play for astute collectors, how they could become trusted allies in the mission to create the kind of collection the Nashers now clearly wanted to create. As Pillsbury pointed out, it is often the dealers who decide who will have the chance to buy what.

Dealers can be both crucial and canny. Joseph Duveen, one of the shrewdest and most powerful dealers of the first part of the twentieth century dealt with the mega rich including J.P. Morgan, John D. Rockefeller, Jr., William Randolph Hearst, and Andrew Mellon. Duveen understood their needs and vulnerabilities. What was an especially effective Duveen strategy was his seeming reluctance to want to sell the paintings he had. A strategy that served to always

deepen a mogul's passion to acquire. Philipp Blom, in his book, *To Have and to Hold*, said, "There was more at stake in those transactions than simply the possession of a great work of art: canonization, admittance into the great chain of previous owners, into the mystique of provenance. . . . Duveen did not sell pictures; he sold immortality."

The triumphant tour of the late 80's assured the art world and especially dealers that the Nasher Collection had arrived. And that meant that the Nashers were now in the most inner of the art world's inner circles. They would be among the first to be contacted when something extraordinary might be coming to market. What Philip Johnson said about the de Menils as collectors applied now to the Nashers as well: "They were unpretentious yet arrogant enough."

At a certain point in a life, the question of how one will be remembered can seep in and in some cases take over. With the National Gallery Show in 1987 and then the European tour of the collection, Ray came to understand that it was the collection and its continued refinement, adding strength to strength, that would overshadow any other achievement of his life including NorthPark. The Nashers and their collection would now be covered and analyzed in the most prestigious and powerful media; the Nashers had clearly become members of the nation's cultural royalty. Their lives would be defined by the Nasher Collection. All other achievements would be

outshone by their collection's preeminence. No one, including the Nashers, could foresee that the glory of this opening would ever be exceeded. But it would be in the fall of 2003.

Patsy's condition would worsen in the months following the National Gallery exhibition. It was now just a matter of time and the strength of Patsy's will that would determine how long she would live. She somehow made it to Madrid for the Nasher opening where she met Queen Sofia. After the Madrid opening April 6, 1988, she could not go on and returned to Dallas for treatment. She did see with pleasure in late June the photographs of one of their sculptures, Tony Smith's *The Snake is Out*, being flown by helicopter across the Florence sky to Forte di Belvedere where the Nasher exhibition would be shown.

Patsy Nasher died in Dallas at 2:30 P.M., July 1, 1988. She was 59. The aggressive treatments of the cancer she bravely endured had helped but not enough. This independent woman's life was celebrated on Independence Day, July 4, 1988 at Dallas Temple Emanu-El. At the funeral Rabbi Zimmerman said that "Patsy had a mind that knew it never knew enough." In that regard, she was like all the best explorers.

The family believed, as Patsy did, that the show must go on. The family, therefore, returned after the funeral to Florence for the exhibition of the sculpture collection. The Nasher family held a small serv-

ice in Patsy's honor there at the Forte Belvadere on July 8th. Andrea Nasher read the poem "Ithaca" by Constantine Cavafy.

Here are some excerpts:

> *When you set out on your journey to Ithaca,*
> *pray that the road is long,*
> *full of adventure, full of knowledge . . .*
>
> *Pray that the road is long.*
> *That the summer mornings are many, when,*
> *with such pleasure, with such joy*
> *you will enter ports seen for the first time . . .*
>
> *Ithaca has given you the beautiful voyage.*
> *Without her you would have never set out on the road.*
> *She has nothing more to give you.*

Patsy Nasher's road had not been nearly long enough. But it had been just long enough for her to see the results and recognition of her collecting voyage.

Collecting became Patsy Nasher's Ithaca, giving her life a singular purpose collecting provides the few who learn their lessons well, whose focus and passion never abate.

Ted Pillsbury is now the director of the Meadows Museum at SMU. He recognizes the power and influence collectors have on museums and their boards. Their collections are essential to sustain-

ing and amplifying museum reputations. And yet, Pillsbury maintains, "Every collector is haunted by something." Even a collector with Ray Nasher's reputation.

When you look at the catalog of the Nashers' Collection, among the masterpieces you will find the following:

- Brancusi's *Nancy Cunard* (Sophisticated Young Lady) (1925–1927)
- Max Ernst's *Capricorn* (1948)
- Giacometti's *Chariot* (1950)
- Carl Andre's *Aluminum and Magnesium Plain* (1969)

Each of them carries the same credit:

"The Patsy and Raymond Nasher Collection at the Nelson Atkins Museum of Art, Kansas City, Missouri, Lent by the Hall Family Foundation." Read quickly, they don't make much of an impression. What's unsaid is that these four works were sold by Ray to the Nelson Atkins and that they are now owned by that museum.

Donald Hall is an exceptional philanthropist to both his city and the nation. The source of the family's fortune was Hallmark cards. Many of television's finest hours have been broadcast for decades on the Hallmark Hall of Fame. Hall has also been active over the years in increasing the stature of Kansas City's cultural life including the Nelson Atkins Museum.

During the negotiations in the early '90s about acquiring the mas-

terpieces, Hall agreed to have their description begin with the words "The Patsy and Raymond Nasher Collection . . ." The idea of phrasing the credit this way had originated with the dealer representing Ray on the sale. Donald Hall, who has great admiration for the Nashers and their collection said, "I thought this would make the transaction easier for Ray."

The story behind the sale is understandable to anyone who knows anything about the vagaries of real estate. In the early '90s, almost all Texas real estate developers had problems. While NorthPark could weather the crisis, NorthPark South and NorthPark East had problems. Their cash flows had declined. Ray had also become involved in a one hundred acre development with Exxon's development arm in Friendswood, outside of Houston. There had been a competition to select the developer and as Ray puts it, "I unfortunately won the competition." The big idea was that with Nasher's shopping center savvy and experience and Exxon's financial strength a Houston version of Dallas's NorthPark could be created. But with the collapse of the savings and loan entities, lending had almost stopped and those in real estate investments with significant debt exposure found themselves in a perfect storm. Lenders' loyalty to developers evaporated. Many developers threw in the towel as lenders foreclosed on their properties.

In this kind of situation, real estate investments can be particularly dangerous. These investments are often secured by the value of the

land. The actual cash put up is often a small fraction of the land's value. If the land value plummets, however, the real estate investor has to put up more cash. The Nasher fortune was tied to real estate and art, two great long term investments. But in the short term, Ray needed cash to hold off the lenders and now the government, which had been forced to take over the savings and loans and restructure the massive loans made by commercial banks, in order to protect NorthPark. His only real option to secure the necessary cash was art. And that's why the deal had been struck with Donald Hall and the Atkins Museum; Ray would receive close to $18 million. He used some of the proceeds to pay down his borrowings related to Friendswood and to the NorthPark bank. He stills holds an interest in Friendswood.

Ray found a way through this crisis. He doesn't look back nor does he second guess himself. He understands what Dean Acheson, Secretary of State under President Truman, said, "Regret is the most enfeebling of emotions." Ray doesn't talk about regrets. His expression turns opaque when asked about those problems of the early '90s. What's done is done. Because for Ray, life is always about what's next, and where we go from here.

# COURTSHIP

WHEN DEEDIE ROSE, a collector herself, became president of the Dallas Museum in 1994, she was single minded about what would define her leadership: to find a way to persuade Ray Nasher and his family to give their extraordinary sculpture collection to the Dallas Museum of Art. A friend, in fact, had given her a book about understanding personalities to help her gain more insight into Ray's character in order to persuade him to commit the collection to the DMA. She recalled one section dealing with decision making. At one end of the spectrum is the person who decides quickly. For this person their very decisiveness often makes the decision work. At the other end of the spectrum is the person who gathers and gathers information. The latter clearly described Ray. He had learned in the real estate development and banking business about the power of waiting and how wait-

ing could make good deals better. This was especially true when you held all the chips.

Ray and Deedie both knew Ray held the strongest of hands. There had been another civic situation where Ray didn't hold all the cards and waited too long. The new symphony hall designed by I.M. Pei was built in the '80s. The naming rights for the hall were priced at $10,000,000. A good deal especially when the final bills came in and the hall ended up costing over $80,000,000. Nasher deliberated too long about making the gift in the name of his mother and father, Janet and Israel. Ross Perot stepped in with the requisite ten million dollars and had the hall named after his friend and business associate, Mort Meyerson.

In gearing up her presidency, Deedie Rose and the museum board enlisted Mike Boone, the leader of Haynes and Boone, one of Dallas's largest law firms, to guide them in their efforts to strike a deal with Ray. Rose was concerned about whether the two and a half acres, just to the west of the DMA, could be secured by the museum for a sculpture garden; this was the site she and the Museum Director Jay Gates believed Ray would find attractive. She was, however, worried about The Guggenheim's director, Thomas Krens, and the recent acclaim for the Nasher Collection generated by the 1997 Guggenheim Museum's show in New York City. Krens was ambitious and canny; he liked having a reputation for aggression. The Bilbao under con-

struction in Spain was a Krens initiative. In an economically depressed area of western Massachusetts, Krens was also converting old dormant red brick textile factories into spaces for contemporary art and artists. What Krens wanted he had become used to getting. A visitor to Ray's house in the early '90s remembers walking the grounds with Ray, looking at the sculpture. On the terrace Krens, who was there for a meeting with Ray, watched, the visitor recalled, as though Ray was prey. Which he was, but he was canny and illusive prey. The allure of great crowds only New York museums could generate was a card Krens would later play with Ray following the Guggenheim's show of the Nasher collection.

Carter Brown of the National Gallery had also had serious discussions with Ray about giving the collection to the National Gallery. He had offered prime vacant land next to the National Gallery to create a Nasher Sculpture Garden, right there on the Mall which enjoys millions of visitors every year. Brown did not have to remind Ray that the greatest event of his and Patsy's collecting lives had been the exhibition at the National Gallery in 1987. And Brown could muster all the capital's power elite to help him win the Nasher prize, from the President to the most powerful congressional leaders. The Nasher Collection would be viewed as a great gift not just to a city or a state, but to our nation. And Ray who made it his business to know how many shoppers visited NorthPark every day understood how much

greater the traffic would be for the collection if it was located on the Mall.

Getting Ray to the altar, Boone remembers, was hard. Ray, for his part, was trying to understand just how badly the city of Dallas wanted the collection and how far they would go to get it. The situation was complicated by friction on the DMA board. Some directors felt Ray was using them as a stalking horse. However, the museum proceeded in its pursuit with Deedie Rose and Jay Gates, then the DMA's director, spearheading the initiative. Jeremy Halbreich who was then an executive at The Belo Corporation, a communications conglomerate based in Dallas which owned, among other prominent media properties, the *Dallas Morning News* and WFAA, the ABC affiliate, was advising Rose and the museum. Halbreich was a close friend of the Nasher family. Margaret McDermott, one of the city's most beloved and respected philanthropists, well before the serious quest of the Nasher collection began, had bought a section of the block just to the west of the DMA for possible expansion of the DMA. The remainder of the block was controlled by the Crow family interests for which Harlan Crow was the spokesman. The Trammel Crow Company, a prominent real estate development firm was founded by his father, Trammel Crow.

The city of Dallas led by then Mayor Ron Kirk, was also determined not to lose the Nasher collection. Dallas employs a city man-

ager form of government. The city managers, though unelected, often have more power than the mayors. Nevertheless, a mayor with a strong personality and savvy can have considerable impact. Older citizens cite, as evidence, J. Erik Jonsson, one of the three founders of Texas Instruments, who became Dallas's mayor in the aftermath of the Kennedy assasination. Jonsson, as mayor, knew how to get things done in spite of not having the actual power defined by law. All business leaders always took his calls. He was seen as selfless when it came to what was good for Dallas. Mayor Ron Kirk, who was mayor during the pursuit of the Nasher Collection by the Dallas Museum of Art, also knew how to work the system and use his considerable charisma. On his agenda along with a mass transit system and a new downtown arena, was his determination to keep the Nasher Collection in Dallas.

Kirk worked to get a committee together to help him persuade Ray. Kirk also believed Nancy Nasher and her husband David Haemisegger would be key influences on Nasher's decision. However, Kirk met with resistance when he tried to recruit the committee. "Stanley Marcus told me I was wasting my time. The feeling was Ray would listen to us but would in the end go his own way." After one museum board meeting Ray attended several years before, he turned to a friend and said after a business leader on the museum board made several clueless observations, "How can people with such influence know so little?" Ray, as a Dallas Museum Board member would

ask the unsettling questions. Why did you buy that? Why did you pay that? For Ray it was wide open. He believed having to answer tough questions could strengthen the museum. The gift outright of the Nasher Collection to the Dallas Museum of Art was seen as a long shot. New York and Washington seemed to hold stronger hands.

But Deedie Rose, Kirk and a few others such as Margaret McDermott, would not give up. Kirk met with Ray several times and at one meeting he remembers saying, "They don't build statues to those who create shopping malls." While it didn't need to be said because Ray was, after all, a good history student, Kirk also said, "You don't build a great city without families with wealth stepping up to create institutions that define a city to the world."

The mayor was able to get the necessary commitment from the city council to buy the land controlled by the Crow interests. The Crow interests, Mike Boone remembers, were willing to sell their land somewhat below the market price to make the deal more appealing to Ray. The Dallas Museum, across the street, was also willing to commit significant parking for the Nasher Sculpture Center visitors.

The museum would also contribute, thanks to Mrs. McDermott, its portion of the land they owned across the street on the west side as part of the deal with Nasher. Between the city, Crow, and the Dallas Museum, the land would be secured for the garden. Ray, in turn, the DMA proposed, would contribute the core of his sculpture col-

lection to the DMA which would assume full responsibility for maintaining it. It's important to remember that both the DMA and Ray at this point were only envisioning a sculpture garden with the necessary landscaping. There was no significant architectural component envisioned.

Boone said that while Ray was a tough and formidable negotiator, "he was always committed to doing what was right for the art." And Boone went on to explain, "We were making terms at first Ray would take as negative such as limiting too severely the number of pieces that could be loaned out." Boone believes Deedie Rose was extremely effective and focused throughout the process. She kept her eye on the prize. "She was a great listener and would prepare very carefully for every meeting with Ray," Boone remembers. Rose also made sure to make the case to the city and keep Mayor Kirk and the city manager, John Ware, apprised. Ware promised to get the streets in the area realigned to help the museum's efforts with Ray.

Deedie Rose made a key point that America's great cities could lose opportunities and not suffer greatly. Museums in New York or Boston or Chicago, for example, might lose a collection but their collections were already so deep that the impact would not be crippling. "But Dallas," she said, "is a frontier city and can't afford to lose something of the magnitude of the Nasher opportunity." This is the belief that drove her. Boone remembers how hard she worked to make all

interests converge, from the city to the business community to the museum and its major patrons. Any misstep could have derailed the pursuit. Boone remembers, "Deedie put her heart and soul into this. She brought an emotional urgency and passion to the table. It had a definite impact on Ray. She showed real leadership." She also had exceptional patience that dealing with Ray sometimes required.

Both the city and the DMA worked together that fall of 1997 and gave Nasher their proposal with a deadline of February 13 for him to respond. Nasher had one major distraction and it was a major cause for concern for all those involved. The Nasher Collection was to open in New York at the Guggenheim on February 7th. "That damn Krens," Rose recalls, "was always lurking." This would be the first show for the collection in New York and it could be intoxicating for Ray. So, in one sense, the timing for Dallas could not have been worse. While the museum tried to figure out what direction Ray would go, no one could quite predict what the positions of the three Nasher daughters, each of them independent and discrete, would be. It would be Ray's decision but their influence would be considerable. One source said there was a feeling, in the Nasher family, that there could be a backlash against them if they decided to have the collection go to another city, effectively turning their back on Dallas where the Nasher fortune had been made.

To understand Ray's frame of mind it's worth focusing on some-

thing he said several years earlier about certain people on the museum board with power knowing so little. When asked about his comment, he says, "Too often people stay only within the framework of their own work. They don't pursue the knowledge necessary to relate to art and the environment. Their backgrounds are a blank. They stay within their own power bases—whether it's banking or real estate, oil or technology. They can give money and that's important but they can't give beyond. It's one thing to understand finance, it's another to know what can uplift a city—music, art, the environment, planning. Who doesn't love Paris? Paris didn't just happen. It was the result of a superb master plan and leadership created by Georges Eugène Haussmann."

Rose remembers clearly the day of reckoning, February 13, 1997, and the meeting in Jay Gates's office at the DMA. Ray sat to her right and Nancy Nasher to her left. Museum Director Gates warmly welcomed the Nashers. After the niceties concluded, Ray said they had reached a decision. The Nasher family had decided to build the sculpture center, pay for it, and control it. Rose remembers, "It was stunning. It took me a second. I had never dreamed it would happen this way. Now I understood clearly. We were getting just what we wanted. The collection would stay in Dallas, just across the street from the Dallas Museum of Art. I knew the Nashers would do it their way and it would be uncompromised and committee free." Rose recalls, "I was

exhilarated. Because what Ray would create would reflect his good taste, judgment and architectural insight. He likes to do things his way. And do them right. Look at the collection. Look at NorthPark. They speak for themselves." The Nashers decided they would pay the price never knowing that the scale of the project would be far greater than anyone anticipated and cost over $70 million, three to four times more than the sculpture garden they initially had then in mind.

The decision was made to wait until April 8th to make the announcement in order to get all the necessary players there. Rose remembers this wait being "agonizing." Finally at 10 A.M. at a Dallas City Hall press conference, it became official. The Nasher Sculpture Collection would stay home in downtown Dallas.

The song goes, "It takes two to tango, two to do the dance of love." Nasher liked the feeling of being wooed. Who wouldn't? It was both a pleasant sensation and educational. The wooing gave him time to think about what mattered most to him and that was, he finally decided, eternity. Ray understood promises in the museum world like every other world can evaporate. Boards change, museum directors change, curators change, directions and priorities change. Promises to collectors and artists could be broken. How the Nasher Collection would be treated by anyone but the Nasher family could never be known for sure. For that matter there can be fissures in families that surface in later generations.

Ray, during the collection's courtship, in fact, had asked his long time friend and attorney Henri Bromberg, to draw up a possible agreement with the Dallas Museum of Art for the collection. Nasher would not make gift outright of the collection but the museum would have extensive access to the collection. Ray came to believe that less than total control was insufficient, or worse, could lead to loss of control, not in his lifetime, but sometime. Finally, it became ever so clear that no one would care for the collection with his or his family's intensity. Ray listened politely to all the great seducers of the museum world. And then went his own way.

# RENZO

THE GRANDFATHER of the Italian architect, Renzo Piano, was a builder. Piano's father was a builder. And his brother is a builder as well. He says, "My love of building came from my father. Like the son of an acrobat, no one tells you. You just grow up with it." Piano calls his business, based in Genoa, Italy with a second office in Paris, a workshop, not an architectural firm. That helps explain the exceptional sense his buildings make and what he calls his passion for construction. Which isn't to say, however, his buildings are always a contractor's delight.

BECK, headquartered in Dallas, is one of the most respected building contractors in the country. Nasher has a long standing relationship with the company and Henry Beck, whose company was the contractor on NorthPark and also built Nasher's Miami skyscrapers in

the early 1980's. Neil McGlennon, one of BECK's most capable project manager, would oversee the construction for BECK of the sculpture center. He was in charge of transporting the complex dreams Ray Nasher and Renzo Piano shared to reality.

McGlennon has an extraordinary temperament as well as the building savvy and communications skills necessary to convert dreams and drawings into buildings at a price within shouting distance of the budget. Vel Hawes, who was Ray's own representative on the job, has an architectural background as well and understands Ray's point of view, both what's said and unsaid. At varying points over the course of building the center, Piano would view himself as being outnumbered, a voice in the wilderness. He would advocate perfection—everywhere. In the rest rooms when the tile floor was being laid, they asked Piano where he wanted the last row of floor tiles located so as to fit and the resultant cut tiles be least noticeable. His response was, "We can't cut the tile, we have to move the wall." As McGlennon said there was no way that was going to happen. So McGlennon's team figured out a way to lay the tiles behind the commode. The only ones who will notice will be Piano, McGlennon, Hawes and the men who had to cut the tile.

McGlennon believes the 55,000 square foot sculpture center building with sixty active sub contractors presented challenges and complexities he and HCB are used to finding in a three million

square foot building. The completed building is a portrait of simplicity, full of grace and northerly light. Its serenity belies the gauntlet the owner, architect and contractors had to run.

"I wanted people who visited this site to say this is the cleanest construction site they had ever seen," McGlennon said. "The level of quality construction always is better when the site is kept clean. It also minimizes damage," he believes. The ancient look which Piano and Nasher wanted from the start is being achieved for what they both hope will be a building that will last at least a thousand years. The ancient ruins in Herdonia, Italy, Piano believes, are the Nasher Sculpture Center's forebears. As you walk through the site with McGlennon, as you sit in his office, listening to his stories, he'll interrupt himself and say, "Oh, here's a challenge we had," with excitement in his voice and then describe something they had achieved. All the key people working on the center shared the same feeling, that the sculpture center would be exceptional and anything but just another building.

One source of Renzo's persuasive powers is his ability to use the nuances of English language filtered through his Italian perspective. He talks about Texas as his first love in America because of his work with Mrs. De Menil and the creation of her museum in 1980. He said he was captured by her idea to build her museum in a neighborhood she and her family were helping to preserve. Her museum would be

located, Piano explained, "in the middle of the indifference of the city." The right kind of building, the right kind of open space can provide antidotes to that indifference. The Menil Museum was Piano's first museum assignment in America.

The Nasher Sculpture Center is much closer than either the Kimbell Museum in Fort Worth or the Menil in Houston to the nitty gritty of the city. The Nasher, after all, is bordered on the south by a fifty story office building and on the north by the six lane Woodall Rogers Freeway. More than a year before the Nasher Sculpture Center was completed, Ray invited friends to join him and Piano to have a look at the building under construction. Piano spoke briefly and with great feeling about the building and then he looked up at the huge office skyscraper behind the audience, on the south side of the sculpture center and said, "It's David against Goliath."

The Nasher Sculpture Center would save the land Piano said "from a terrible destiny." The Nasher building would be strong without being imposing. It would not however be neutral which Ray and Renzo both believed is not good for a building. "We both wanted an oasis. Not a citadel," Renzo recalls. What matters most to Nasher is the experience provided to people—whether they be shoppers at NorthPark, visitors to a museum, or those visiting the Nasher Sculpture Center. In each case the treatment of the natural light is crucial. Piano understands this.

Compromises are inevitable in construction. Budgets have limits after all. The trick is to make the compromises invisible so that the experience of visitors seeing the collection is undiminished. Ray does not believe the building belongs to the architect; the building belongs to the collection, in his view. The experience created by the collection should edify and excite the audience, whatever its degree of sophistication. And Piano believes this just as strongly. In his work it's the light that creates the atmosphere, not the architecture. The architecture is there to serve the art. "Many museums," Piano said, "seem to have been realized not in the service of the art but in order to set the stage for the architecture."

"An architect cannot prove everything before the building is built," Piano explains. "That's why the patron has to take a certain leap of faith that what's proposed will work. A musician can show you the actual music he will play. An architect can't show you the building."

When asked how Ray was to work with, Piano said, "Ray was obstinated." It's defined as a verb, transitive, "now rare" which means to persist stubbornly. It doesn't say unpleasantly, just stubbornly.

Over the course of the sculpture center's creation and construction, Andrea Nasher, Ray's oldest daughter, became a significant influence, an enlightened contrarian. She politely took on her father and Renzo Piano and others and at first was treated with polite indifference. This was, after all, a man's world. These activities are

dominated by men: Construction. Architecture. Art. That's just the way it is. Opportunities for women in those worlds may broaden for women. But if the past is a predictor, the speed of women's progress will be glacial.

Andrea, however, found the courage to stand up for her carefully considered positions. She was focused. Her willingness to persist in spite of an absence of support began to have an impact. Those whose support she needed most—her father and Piano—came to understand that she was an advocate of what was right, what would work to create for visitors the best, most memorable experience with the center, the garden and the art. They could see what she advocated had nothing to do with wanting her own way and everything to do with the future impact the center would have on citizens, and the pleasure of their experience. One of the things that drove Andrea, according to a member of Piano's team, was the fear of growing old and not speaking up, knowing that the sculpture center wasn't as good as it could have been.

In the early stages, Piano wanted to have a roofing system like the one he had used at Ernst Beyeler's distinguished museum on the outskirts of Basel. Both Ray and Andrea believed the sculpture center deserved its own solution.

The Nasher team met with Piano and his team in Arenzano, Italy in February, 2000. At this meeting Andrea urged that the roofing sys-

tem allow more natural light for viewing the sculpture. She made her case. Then there was silence. Finally Renzo grabbed a pencil and paper and sketched out a sunscreen system for the roof. He finished, smiled and hit the table. Piano and his team went on to create a breakthrough, a roofing system which he describes as sculpture "whose little eyes are always watching for the northern light." This new system, he said, would "create a vibrant magic light, not a flat light." They first considered plastic for the lighting filters but finally settled on the more substantive cast aluminum. The light would become a key definer of the experience visitors to the sculpture center would have.

Piano and his colleagues created an all new system. "When I first explained it to Ray, Renzo said, "I understood 50%, Ray 25%. The second time we met on it, I understood 75%, Ray 50%." Ray said, "Great, let's go." He had heard enough. Piano views intelligence in two ways, light and heavy. Light intelligence he admires because it's less rigid and dogmatic. It wants to understand but broadly and makes room for a leap of faith when necessary. Nothing comes close, however, to the leap of faith architecture requires from all parties. For obvious reasons. No model can depict actual size and corresponding impact. The role of materials and the influence of light have to be imagined. Few human activities require the light intelligence architecture demands. Piano says "Ray put immense time into the project. He came to

Genoa many, many times. I came to Dallas 10 times." Piano exaggerates to create the effect he wants—that Ray was deeply involved. Piano also maintains the ideal client doesn't give you the solution. He also says there is no good architecture without a good client. All of this, in a certain way, beats around the bush. Some days Ray and Piano saw themselves as in this together while other days they were at odds. They were combatants and allies both.

Ray is not confrontational. He nevertheless likes to see decisions debated. And debated. He sees decisions deferred as sounder. Additional time to reflect exposes new possibilities and nuances—or weaknesses—to consider. Buildings are generally around for a long time; weaknesses in the design or construction will remind all concerned they could have been done better. Piano says he is jealous of writers who can make corrections as their books go from one printing to the next. A building that breaks entirely new ground—and that's what both Ray and Piano wanted—poses even more risks than pedestrian architectural solutions that are cookie stamped out. In the back and forth process between client and architect Ray wanted Piano to be both happy and to fight—up to a point—for a building of distinction. It helped that Piano has an excellent sense of humor. Until you say no.

There was inevitable tension resulting from clashes between three perspectives—there was the owner, Ray Nasher who was anything but

passive and completely comfortable asking uncomfortable questions; and there was the architect, Renzo Piano whose work had earned worldwide renown; there were other players as well, including the landscape architect, Peter Walker. They were all used to getting their way. At one meeting with the landscape architect's team, a small reflecting pool still remained in the plan that Ray had wanted eliminated. It would have taken up valuable space needed for sculpture. Peter Walker could not attend that particular meeting; his team told Ray that Peter felt strongly about leaving the pond in. Nasher said, "I feel strongly about it too, and I can't believe it's still in the drawings— get it out." There was another incident with the landscape architects at dinner at Ray's house; he pulled them aside as they walked around his grounds and told them, "Look!" This is what he wanted—the feeling of the sculpture fitting into the landscape naturally. He didn't want just another museum style sculpture display. Ray wanted artists to feel their work was at home in the Nasher Sculpture Center. It was an open and shut case as far as Ray was concerned. No more debate. Just do it.

Initially the sculpture center building was going to be located at the center of the western wall along Harwood Street. That would be the entrance to the building. As visitors came in this entrance they would look across the garden, approximately 100 feet, to the eastern wall. The sculpture center in this location would intrude on the gar-

den. Visitors would be unable to have an immediate view of the garden in its entirety. For several months the sculpture center building entrance was going to be located at the northern end; at this point the Nashers believed the only parking for their visitors would be available in the Dallas Museum of Art's underground garage; the northern end would be closer to the garage. Over the course of three months, however, agreements were made with the Crow family to use their parking on Flora, just across from the center's southern boundary.

Finally it was decided to have the sculpture center entrance located along the southern perimeter. This would enable visitors to enter and be able to see at once the full expanse of the garden's openness across two acres to the northern boundary. There would be no skyscraper overpowering the garden. The visitors' engagement would now begin at once with a vision of the full garden. This decision took months because of all the other decisions being made.

At the north end of the sculpture garden, visitors now have, perhaps, their most unusual experience thanks to James Turrell's site specific work *Tending* (*Blue*). There, inside a square black granite cube 26 ft. x 26 ft. x 26 ft., visitors can sit on the interior's stone benches angled back so they can look more easily at the sky through a ten-foot by ten-foot opening in the middle of the ceiling. The experience at dusk and dawn, especially looking at colors, some of which we seem to be experiencing for the first time, is unparalleled. Turrell has said,

"I want to create an atmosphere that can be consciously plumbed with seeing like the wordless thought that comes from looking in a fire." The full experience requires from us such endangered human responses as ". . . silent contemplation, patience and meditation." That familiar phrase, "See for yourself," comes to mind inside Turrell's space and how easy it is to forget how. In a certain way, a few dusk or dawn visits to the Turrell may help us see the entire collection more deeply. The Turrell is a brave addition.

The migration of the sculpture center building location from the west to the north to the south is a good example of what mattered to Renzo and Ray. The imperative for them was not about making quick decisions. It was all about what will be the best possible answer for a long, long time to come for all those who visit, who take the time to experience what was being created.

In architecture and construction there is an extraordinary amount of pressure put on the mind's eye and the ability to imagine and fore-see the full scale of a project. Blueprints and models cover just a tiny fraction of actual size. What gets built, whether great or mediocre, stays built. Over the course of the design and construction, Andrea had the good fortune to be able to give her perspective to Renzo and her father, each of whom had an exceptional mind's eye. Her perspec-tive helped. She was a major supporter of Turrell's *Tending (Blue)* being added to the sculpture garden. As Andrea looks back, beyond

the battles, she says, "It was a time I could work with my father. What a gift! I had never done that. I feel blessed."

During the midst of construction, well over a year before the October, 2003 opening, there was a meeting in a construction trailer on the site of the sculpture center. Over twenty people were there including Piano and Ray who was heading to New York as soon as the meeting concluded. One of the issues to be discussed was whether to add six trees along Flora Street near the west side of the sculpture center. Ray had originally wanted the trees. Piano had not wanted them because he felt they would impair the view of the building and diminish its visual impact. Nasher finally gave in. Now Piano had changed his mind; he wanted the trees. The change would add several hundred thousand dollars to the cost which was already millions of dollars higher than the original budget.

In the meeting, Piano made his case for the additional trees. Ray asked Vel Hawes, his representative on the job, what it would cost. Hawes said, "Over $300,000 for six trees." And Ray said simply, "I can't afford it." Hawes replied, "Fine." Piano stopped the meeting. "Fine? What do you mean fine? Ray, you're breaking my heart. I'm an old man. No one listens to me." He went over to the landscape architect's drawing and ripped it, saying it's mediocre. All of this happened right at the end of the meeting. Piano went out for some air. Ray had to leave for the airport. The next day, Ray told Hawes, "If we can

come up with a solution for $100,000, I'll do it." And that's what they did. A week later a letter from Piano arrived. Here are excerpts.

Ray, I can't anymore make my voice heard by you.

. . . Ray, please, I do believe this is a very important matter for the integrity and the beauty of the scheme, otherwise I would not write to you in this way. Don't put myself in the extremely uncomfortable position of the unheeded architect: the design of the Flora Street front of the building is getting so far from my original concept that I find more and more myself unable to recognize it as mine.

Love, respect and trust between client and architect are an essential element of success for an adventure like this: I am ready to solve all the problems and to work very hard but don't take away from me the joy, the duty and the responsibility of the architect.

This letter's intensity of conviction, notwithstanding some exaggeration, helps explain why so many institutions choose Piano and his Building Workshop. In Manhattan alone, the New York Times headquarters building and the Morgan Library renovation, both Piano projects, were underway. The $200 million renovation of the Art Institute of Chicago was coming up and the $130 million expansion of the High Museum in Atlanta as well. In Texas he was doing the Nasher Sculpture Center. The Menil Museum in Houston, his first

building in America, was completed in 1987. He designed Ernst Beyeler's museum near Basel in 1997 which Ray admired. But Piano is not a gun for hire to do what he's told. He is a fiercely independent creative spirit with an eye on eternity. Piano, as charming and engaging as he is, is foremost, in his own mind, a heretic.

> . . . For decades I was sort of an outcast, blacklisted from the clubs, the schools, the academies. As a true neer-do-well this excommunication has always been a source of satisfaction. To a degree, I have now been admitted to the "temple." Maybe I liked it better before.

Looking back, it now seems inevitable that Nasher, an outsider himself, would want Piano committed to create the capstone of the Nasher's life.

When Ernst Beyeler was asked why he chose Renzo Piano to design the museum he and his wife, Hildy, built outside Basel to house their renowned collection, he said simply, "Two reasons: The Pompidou in Paris and the Menil Museum in Houston." Beyeler remembers, "Before I chose Renzo, I thought I might hold a design competition, but I was in a hurry. I just went ahead and picked him because I liked the originality and brashness of his Pompidou Centre in Paris and, by contrast, the quiet human scale of the Menil Museum

in Houston." Beyeler saw in the Pompidou a strong, independent, unexpected statement; in the Menil Museum he saw a personal, restrained building that fit carefully into a Houston neighborhood. Beyeler, who is considered one of the world's most astute art dealers and collectors, summed up why Piano's museum work stands so distinctly apart: "Renzo never relinquished his concern that the art remain the central focus of the project."

Before choosing Piano, Ray talked with Beyeler about his own plans for the Dallas sculpture center and his desire to work with Piano. Beyeler told Nasher that for him the experience of working with Piano had at times seemed like a long hard battle. You can sense that from Beyeler's graceful and politic comment about working with Piano: "The exchange was so intense that we both emerged in the end with a feeling that each of us could now enter the other's profession: Piano could become a collector and I could build the next museum."

Contretemps between strong men of achievement are inevitable. What makes such a collaboration work is the shared conviction, in the Nasher-Piano case, that the building have true distinction and serve both the art and the visitors. Looking at a Renzo Piano museum, you sense an ego in check. Piano's observations about the Beyeler are revealing: "Seeing the site in Richen, I thought, it's so beautiful and the artworks are so profound, one needs to be very quiet. Only silence

can allow one to become fully aware of the unfathomable depths of these works of art. The building became what it had to be: almost discrete." That quality of being discrete has all but disappeared in the culture which craves the spotlight and celebrates self absorption. Piano's work, however, reminds us that architecture can be both quiet and powerful. And that a building truly devoted to the display of art and its impact on visitors has not an option but a duty to be discrete.

At the time of the announcement of the Pompidou's architectural competition in 1970—which eventually drew 681 entries—Piano and his fellow architect, Richard Rogers, both just over thirty, shared a studio in London. They had been encouraged by the Ove Arup engineering firm in London to take part in the competition with them. Why not? Piano and Rogers had nothing to lose. Their reputations had yet to be made. Piano and Rogers could not foresee they would be what Benjamin Disraeli called, "A dark horse which had never been thought of . . . that rushed past the grandstand to sweeping triumph." Piano remembers ". . . we knew the competition would be stiff so we decided to hold nothing back." Piano as a little boy, self described as disobedient, whose father and grandfather were both builders, became an architect with strong convictions, "I think it is right to connect disobedience with independence of thought." Independence of thought would carry the day in the Pompidou competition. That's when Renzo Piano's ascent began. Fate is funny. Without

the Pompidou project, would Piano's career have taken him to Ernst Beyeler whose museum would influence Ray Nasher's choice of Piano for his sculpture center?

When they won the Pompidou competition, Piano and Rogers saw no need for compromise or to soften or temper the boldness of their ideas. More than two decades later Piano recalls that the Pompidou, ". . . was to some extent a form of civil disobedience. It represented the refusal to inflict an institutional kind of building on a city already over-burdened with memories. But dumping this out-of-scale object, dis-turbing in its dimensions and appearance, in the center of Paris (creating an effect a bit like that of an ocean liner passing through the Giudecca Canal in Venice) was obviously a deliberate taunt aimed at the most conservative sort of academicism . . . Perhaps it is also the fault (or the merit) of the Centre Pompidou that my career as an archi-tect has been a long series of heresies." Renzo's heresy is his belief that a building can be for the people and be embraced by them and yet still be full of grace that timeless design creates. That we feel good in a Renzo Piano building, that we feel charmed, gives Piano deep pleasure.

Ray's choice of Renzo Piano seems now, in retrospect, inevitable. Ray greatly admired the Beyeler Museum and considered Beyeler to be one of the most civilized of men. Piano's work also connects to the Nasher house where the natural light imparts such a feeling of well being. The Nashers moved into their house, designed by Howard

Meyer, a disciple of Frank Lloyd Wright in 1961. Following Patsy's death, Ray thought briefly of moving and then decided to stay because there was to his mind and Patsy's no prettier piece of land in Dallas. He talked to a number of architects many of whom wanted to tear the existing house down and start over. Ray finally decided to use an architect who was an admirer of Meyer, the house's original architect. The house was renewed but kept faith with its original design.

A sense of home is so important to us. It's clearly important to Ray Nasher who has lived now in the same house for more than forty years. The architect Louis Kahn said, "So you should never lose sight of the home, because a person coming from his home to a place away from his home must feel he is in a place where home is not away from him." That's the secret Beyeler, Piano and Nasher understand. The subtitle of Piano's book on the Beyeler Museum in fact is *A Home for Art*. We need that sense of feeling at home in our buildings. The Nasher Sculpture Center invokes that feeling. The intimacy of the building furthers the intimacy of our individual experiences in seeing the sculpture for ourselves.

When the Nasher Sculpture Center opened in October 2003, Nancy Nasher, the youngest of the daughters, said, "I believe my father is embracing my mother through the creation of the Sculpture Center. The building embraces my mother's commitment to collecting."

# TRINITY

WITH THE OPENING of the Nasher Sculpture Center, there is now a distinct Texas Trinity: the Kimbell Art Museum in Fort Worth which opened October 4, 1972, the Menil Museum in Houston which opened June 7, 1987, and now the Nasher Sculpture Center which opened October 20, 2003. Each is a private museum; each is self funded. None of the three is burdened by the need for any significant public funding; none has to deal with, to use H.L. Mencken's phrase, "the booboisie" comprised of certain appointed or elected, local or state officials. The Kimbell and the Menil are now considered distinguished architectural landmarks; the Nasher Sculpture Center immediately became one.

Kay Kimbell was a native Texan born in 1887 and raised in the small Texas town of Wheelwright, just northeast of Fort Worth. In

1924, Kay Kimbell moved from his hometown of Wheelwright to Fort Worth where he made his home and created the headquarters for his wholesale grocery business. He would make Fort Worth home for the rest of his life. The de Menils, John and Dominique, were French. Mrs. De Menil was a member of the wealthy Schlumberger family; her father created the breakthrough for mapping subsurface rock bodies vital to the discovery of oil. She and her husband moved from France to Houston in 1940 where Schlumberger headquarters were relocated after the French surrender to the Germans. Ray Nasher, born in Boston in 1921, is a first generation American; his father Israel, a Russian Jewish immigrant came to America in the late 1890's. Nasher moved from Boston to Dallas in the early fifties when he married his wife, Patsy.

This trinity reflects strong-willed patrons and the strong-willed architects Louis Kahn and Renzo Piano. Kahn, in fact, was engaged by the de Menils in 1972 to be the architect for their museum because of their admiration for the Kimbell Museum. But with the death of her husband John in 1973, and Kahn's death in 1974, Dominique de Menil stopped the project. In 1980, she was ready to go forward again. This time she chose Renzo Piano to be her architect for a museum to be situated adjacent to the Rothko Chapel. It would be Renzo's first building in America. Calvin Tompkins wrote of Piano's choice, "There was some dismay among the de Menil children over

the choice . . . some of them would have preferred an architect more inclined toward important visual statements; Piano's work tended toward understatement and vernacular simplicity."

Mrs. de Menil was attracted to Piano because of his engineering background and because his buildings, she believed, were designed from the inside out. Walter Hopps, an exceptional curator and the first director of the Menil Museum, remembers the height of the building was of crucial importance to Mrs. de Menil. She and her family had bought most of the neighborhood whose gray wooden homes were modest and simple. She insisted that their museum not overwhelm those homes or their neighborhood. She wanted the museum to be large enough on the inside but intimate on the outside. Piano would figure out the riddle. To make the challenge more complex, she said she would determine the building's height.

Mrs. de Menil took a very straight forward approach to the height issue: She eyeballed it with a helium balloon tied to a rope wound up and down by an assistant. Mrs. de Menil and Piano walked the perimeter of the building's footprint; she would have the balloon navigator reel the balloon up and down at her direction. Mrs. de Menil would check the balloon's height in relationship to the neighborhood's trees and houses. Finally, with Piano following along, bemused, Mrs. de Menil made the decision; looking up at the balloon she said the museum could be no taller than that, two or so stories

high. Hopps remembers Piano saying, "This is crazy but I think I can do it."

The Menil Museum Piano completed in 1980 makes just as much sense today as it did the day opened. In this museum, you can see how much the experience of the museum's audience mattered to both Mrs. de Menil and Piano. This was his first museum in America. Its principles of design would carry through to the other museums he would design. The best architects are like the best writers; they have their own styles which identify their work. But every building, like every good book, provides its own distinct experience.

Louis Kahn's Kimbell Museum was named after the donor, Kay Kimbell and his wife, Velma. They put up all the money, their collection and a generous endowment. Like the Menil it would be a brand new museum. What the Kimbell's collection lacked in stature, the Kimbells made up for with the financial resources they gave outright without virtually any strings or idiosyncratic wishes attached. Kay Kimbell's only directive, before the age of mission statements, was, "Build a museum of the first class." It's hard to imagine a more concise directive. Or a directive better followed.

Neither the de Menils nor the Nashers in the beginning had carefully thought out plans or clear directions for the collections they would create. You can make the case that the Nasher's collection began with Patsy Nasher's gift to her husband of a Ben Shahn

gouache in 1951. The painting was purchased from Edith Halpert's Downtown Gallery. You can make the case that the friendship the de Menils made with the Dominican father Marie-Alain Coutourier was perhaps the precipitating event of their collecting. Coutourier was knowledgeable and passionate about art and the role of collectors and museums. He said, "A museum should be a place where we lose our head." Another strong influence on the de Menils was a Greek, dealer, Alexandre Iolas, with galleries in both America and Europe. Mrs. De Menil said, ". . . he was himself so convinced of the importance of what he was showing. I remember my skepticism in front of our de Chirico, Hector and Andromache. I was not taken in; I bought it on his word, on faith." Looking back from the vantage point of seventy years later, those artists collected by the de Menils seem now like such safe bets. But those artists were just emerging and it took trust for the deMenils to commit to Iolas's enthusiasms. The de Menils and the Nashers were fast learners. And the de Menils, following World War II, like the Nashers later, came to depend most on their own instincts.

Losing a battle can serve to either strengthen or weaken a leader's will. Richard Brown who became director of the yet to be built Kimbell Museum in 1966 came from the Los Angeles County Museum of Art; he had spent seven years there as chief curator and four years,

1961 to 1965, as director. In the late '50s the L.A. museum's board and Brown had decided to build a new museum. Brown wanted Mies van der Rohe to be the architect; Brown understood the magnetism a great building could create and what it could mean to the city, to the museum and its collection and to patrons and collectors. He fought hard but the conservative trustees prevailed and chose, instead of van der Rohe, William Pereira who was known and admired in Los Angeles business circles for his corporate work.

The building Pereira designed for the museum was functional but undistinguished. Brown would soldier on through the design and building process but he had learned his lessons well, lessons about power and having the necessary votes in hand before any election was held. When the building was completed, he was ready to move on and determined not to lose another battle over an architect's selection. For the record, the L.A. Museum board, at the beginning of the twenty first century, decided to correct the mistake made almost 40 years before and tear down the Pereira building. However, a difficult economic climate for raising the funds necessary to build a new museum in its place made the board reconsider and wait until they were certain they could raise the necessary funds. The building still stands.

Museum commissions are among the most coveted by architects. Perhaps it has to do with the association they will have with the

greatest artists and their work. The design of a museum makes architecture, perhaps, less of a trade and more of an art. In the Architectural Program of June 1, 1966 for the new, yet to be built Kimbell Art Museum in Fort Worth, Texas, the new director, Richard Brown, wrote about the kind of museum he and his board envisioned. The common sense, of what Brown wrote, his respect for the Kimbell's future visitors sent a civilized but heretical shot across the bow of the architectural profession. Why? Because Brown laid out requirements for a museum whose architecture would serve ordinary people, whose presence for some architects and museum professionals, is still something more to be endured than to be celebrated.

Here are a few of those heretical points Brown made:

... the building will exist to enable as many people as possible to experience these objects as effectively and as pleasantly as possible: the confrontation of object and observer.

Even though hopefully the building will be a creative contribution to the history of the art of architecture, the building itself should play a supporting role to the reasons for its existence, not a dominating role.

Architectural gymnastics for their own sake work against these reasons. As in verbal expression, when an alternative is presented

between the use of a long complicated word and a short simple one, the latter is invariably the better choice.

 The overwhelming percentage of people whom this building is intended to serve will not be art historians, other architects, or progressive artists with a sophisticated background in architectural form.

Among other experiences, educational and personally enriching, a visitor to an art museum ought to be *charmed*; otherwise why should we expect him to come?

 Think of the word charmed and its definitions—enthrall, captivate, delight. Shouldn't this always be the objective of museums and their architects?

Brown, long before Louis Kahn was selected by the Kimbell Board, tipped his hat unconsciously in favor of Kahn when he wrote, "If natural light were excluded completely, the art, and eventually the museum visitor, seems vacuum packed in a can."

Louis Kahn, a master of concrete and light, was chosen as the architect of the Kimbell Museum by Brown and the Trustees. Kahn, as it turned out, had a significant influence on the Genoan architect, Renzo Piano, who became the architect of both the Menil Museum in Houston and the Nasher Sculpture Center in Dallas. This remark-

able trinity says all that needs saying about how architecture, grace and natural light, and the wisdom essential to all true breakthroughs can create truly pleasurable museum experiences. These three destinations, the Kimbell, the Menil, the Nasher underscore the difference between pleasure and obligation, between a building we can like on our own terms and something we are told we should like. Richard Brown's foresight looked to the architecture to provide the kind of experience he believed the Kimbell should provide all its visitors.

And what is most essential to that experience? For Louis Kahn, a sense of home was what a building should provide. Kahn also wanted visitors "to always know if it's morning, afternoon, or night." And you clearly know this in the Kimbell, the Menil and the Nasher Sculpture Center. And why is the natural light so important? "Because it is the light the painter used to paint his paintings," Louis Kahn said. What will make these three extraordinary buildings—the Kimbell, the Menil Museum and the Nasher Sculpture Center—and the experiences they provide endure was summed up in a handwritten letter written by Louis Kahn to Velma Kimbell June 25, 1969, just a few days before the Kimbell's groundbreaking. "Even serving the dictates of individuals you still have no client in my sense of the word. The client is human nature." Think how much better all our cities, all our museums would be if the power elite and their architects believed their client was human nature.

# ETERNITY

COLLECTIONS ARE KINGDOMS which confer their own power and glory to their collectors. A collection, Phillip Blom wrote, "represents the ultimate in control over others, first the artists whose work is represented and then over the audience and as to where and when and what they can see at a given time." A collection becomes for the most committed of collectors the epitome of their desire.

The desire of collectors can be so strong, so riveted on eternity that they are willing to do whatever is required to never have to part from their collections. Some are restrained. In the Folger Shakespeare Library in Washington, D.C., a small stone plaque off the main reading room marks the place where the ashes of Henry Clay and Emily Jordan Folger, its founders, are deposited "for eternity" as the text proclaims. Henry Huntington chose to build a mausoleum for himself at

the Huntington Library in Pasadena. But no one took the bull by the horns quite like the Englishman Sir Arthur Gilbert to ensure death would not require he part from his collection. Gilbert had moved to California from England where he made a fortune in American real estate in Beverly Hills during the 1950's and '60s. But when the time came to decide where his exceptional collection would go, he chose England. He gave his collection of silver, gold and diamonds to London's Somerset House, located next to the Courtauld Institute. This was after negotiations had broken down with an American Museum. Why? Well, his collection, let's put it this way, did not come without certain strings attached. Sir Arthur required, "that his Beverly Hills office be recreated as a part of the display, including the original Louis XV furniture, pink walls, family photographs and portraits and a life size wax figure of the man himself, sitting at his desk in tennis shorts, smiling stiffly, telephone in hand." Sir Arthur still remains on the phone, perhaps on hold, somehow overseeing his collection from which he refuses to be separated.

There is the story of Cardinal Mazarin, a driven collector himself, who had considerable political influence as tutor and chief minister to Louis XIV. The cardinal, the story goes, toward the end of his life, in 1661, walked through the immense collection he had helped create "muttering over and over, 'All this must be left behind.'" You would have thought the cardinal, a Catholic after all, would have been look-

ing forward to eternity. Maybe he knew something we don't. It just goes to show that eternity can seem like a long time without your collection to keep you company.

Do collections confer immortality on collectors? Who knows for sure? The Nasher Sculpture Center is funded by Ray. He chose the location and Renzo Piano. Ray oversaw the construction. He and Patsy chose the collection. When Renzo said the sculpture center would last a thousand years, Ray smiled. A thousand years is at least a start on forever.

Just as the most important words on maps for ancient explorers were "terra incognita," the most important object for a collector is the next one. The most exciting acquisition always lies ahead, shimmering somewhere over the horizon. This epitome of desire still drives Ray.

Great reputations are reconsidered. An artist's career comes to an end. A ruler's power passes. And the collectors? Collectors go on because their collections go on. A collection can bestow a kind of permanency to the tracks left by a life.

Ray, having been brought up in two great cities, Boston and New York, believed something Louis Kahn said, "A great city should be a place where a little boy should be able to walk through it and see what he wants to do for the rest of his life." Patsy and Ray had faith in the transformative powers of art, that children who had the right expo-

sure to sculpture and painting could develop their own eye and sensibility. He believes that the sculpture center can provide watershed experiences for children just as his visits as a boy to the van Gogh at the Boston Museum of Fine Arts had done. The Nasher Sculpture Center could be a civilizing force making it possible, perhaps, for children to see early what they want to do with the rest of their lives.

# EPILOGUE

"One of the most beautiful things I've ever seen," said Walter Hopps, one of the most insightful, creative curators of the last half of the 20th century, "was the way Jim Sweeney presented Brancusi in the old Guggenheim Museum. To get three dimensional objects set in open space so that the vantage points all work and they reflect on each other right is a bitch. You put any two objects near each other and they start a discussion—it's either an interesting one or it's trouble. Sweeney was masterly at that. I can't imagine ever seeing any one of those Brancusis any better."

Isn't this then at the heart of the matter? To see better, deeper, to see the light only the most insightful collections can provide requires getting all the elements, all the subtleties right.

The caliber of the collection. The imagination and flair of its

installation. The building's alliance with the light. The Nasher Sculpture Center gets it right. In the home Renzo Piano created.

See for yourself. At 2001 Flora Street, on the northern edge of downtown Dallas. The sculpture collection, the garden, the building. The Nashers' epitome of desire.

# A NASHER ALBUM

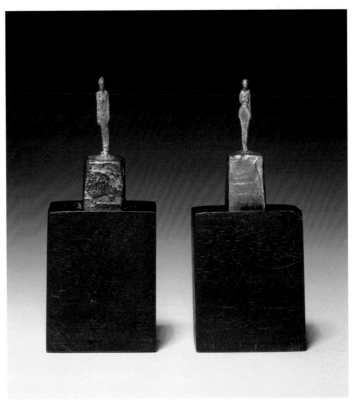

Smallest sculptures in the collection, Alberto Giacometti, *Two Figurines*, 1945, Gold leaf over metal, 1 ⁷⁄₁₆ in. x ⁷⁄₁₆ in. x ⁷⁄₁₆ in.

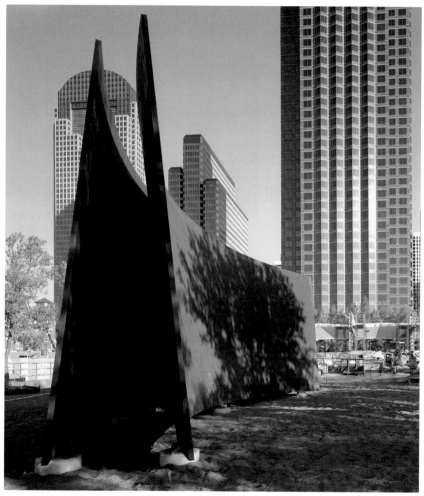

Largest sculpture in the collection, Richard Serra: *My Curves Are Not Mad*, 1987, Cor-Ten steel, 14 ft. x 44 ft. 11 ⅜ in. x 2 in., 100,000 lbs.

Patsy Rabinowitz, age 2    Ray Nasher, age 5

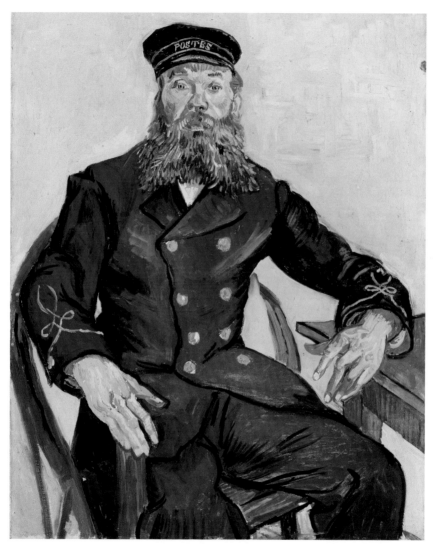

Vincent Van Gogh: *Postman Joseph Roulin*, 1888, Oil on canvas, 32 in. x 25 ¹¹⁄₁₆ in. Photograph © 2003, Museum of Fine Arts, Boston.

Patsy Rabinowitz, age 16, Hockaday Junior College

Ray Nasher, age 21, Duke University

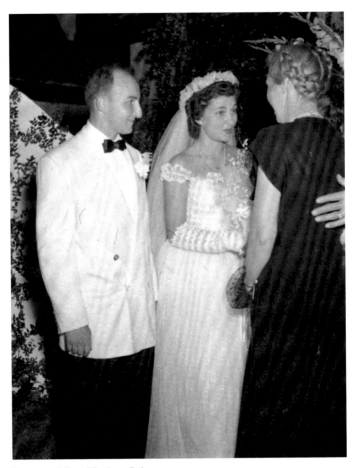

Patsy and Ray Nasher, July 25, 1949

Nasher daughters, Joanie, Nancy, Andrea

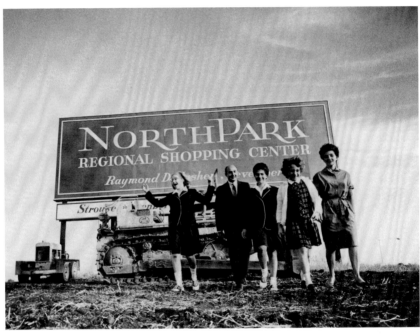

Nasher family—NorthPark site, spring, 1963, (left to right) Andrea, Ray, Joanie, Nancy, Patsy

Ray Nasher at NorthPark clearing

Patsy and Ray at NorthPark

Patsy and Ray at NorthPark, Neiman's mall entrance

Ray at NorthPark

Beverly Pepper: *Dallas Land Canal*, 1971, Cor-Ten steel, 60 in. x 70 in. x 263 ft.

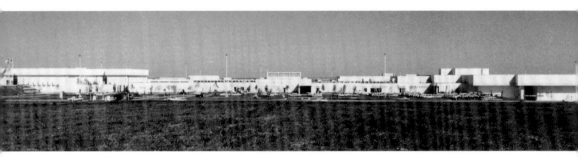

NorthPark from Northwest Highway perspective

Man-made environments can be works of art,
tributes to man's sensitivity, profit centers.
NorthPark Center, Dallas, proves it. It is a giant
marketplace. A garden. An entertainment center.
Mankind's largest climate-controlled mall. With
sales-per-square-foot the highest of any major
shopping center in the nation. NorthPark's owner
and developer, Raymond Nasher, had the acumen to
call in a team of architects first. Together they
created an artistic and commercial triumph. And
winner of a "Best Design of the Decade" award
from the AIA. If you influence planning, find
out how you can profit from an architect. Write to:

**AIA/AMERICAN INSTITUTE OF ARCHITECTS**
1785 Massachusetts Avenue, N.W. Washington, D.C. 20036

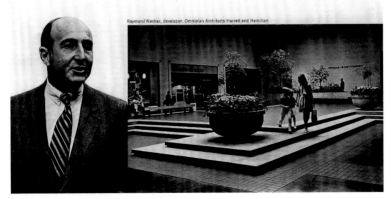

Raymond Nasher, developer. Omniplan Architects Harrell and Hamilton

AIA Award

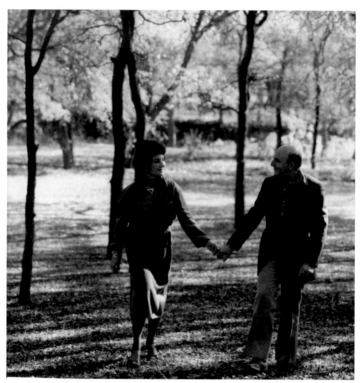

Patsy and Ray at home on Miron; the shaded landscape reminicent of Cezanne's *Farm in Normandy: The Enclosure* (on facing page)

Paul Cezanne: *Farm in Normandy: The Enclosure*, Oil on canvas, 19 ½ in. x 25 ¾ in.

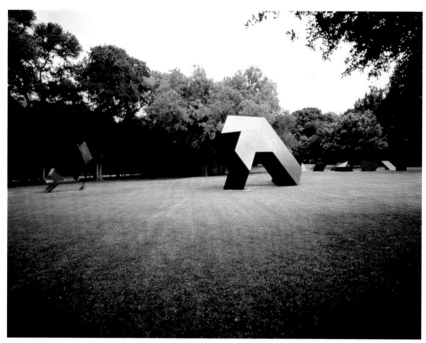

At the Nasher home on Miron, left to right: Mark Di Suvero's *In the Bushes*, 1970-75, Painted steel, 11 ft. 10 in. x 10 ft. 6 in. x 6 ft. 9 in. Tony Smith's *The Snake is Out*, 1962 (fabricated in 1981), Painted steel, 15 ft. x 23 ft. 2 in. x 18 ft. 10 in., and *Ten Elements*, 1975–79 (fabricated 1980), Painted aluminum, tallest piece, 50 in. high, shortest piece 42 in.

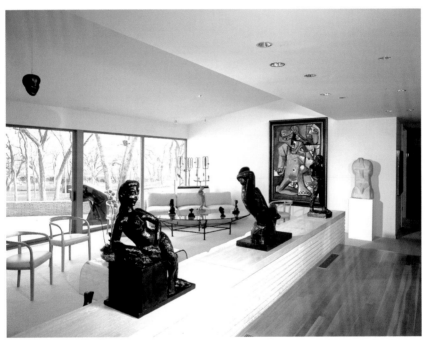

Living room at Miron, including Henri Matisse: *Decorative Figure*, 1908, cast early 1930s, Bronze, 28 ⅜ in. x 20 ⅜ in. x 12 ⅜ in., *Large Seated Nude*, ca. 1925–29, Bronze, 30 ½ in. x 31 ⅝ in. x 13 ⅝ in., *Standing Nude, Arms on Head*, 1906, Bronze, 10 ¼ in. x 5 ¼ in. x 4 ¼ in., Henri Gaudier-Brzeska: *Hieratic Head of Ezra Pound*, 1914, Marble, 35 ⅝ in. x 18 in. x 19 ¼ in., Pablo Picasso, *Nude Man and Women*, 1971, Oil on canvas, 6 ft 4 ⅝ in. x 4 ft. 3 ⅛ in.

Ray at gallery on Miron, 2003
surrounded by works by Rodin,
Giacometti, and Arp.

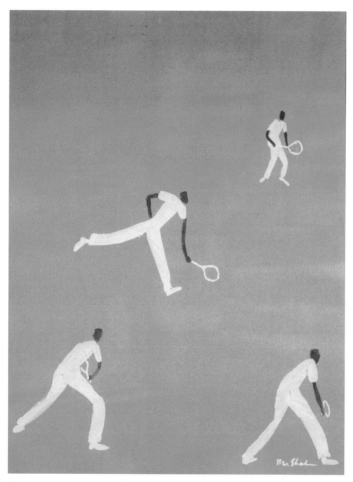

The first painting, acquired in 1950, Ben Shahn: *Tennis Players,*
Watercolor, 17 in. x 13 in.

Jean Arp: *Torso with Buds*, 1961, Bronze, 6 ft. 1 ⅞ in. x 1 ft. 3 ½ in. x 1 ft. 3 in. The Nasher's first great aquisition.

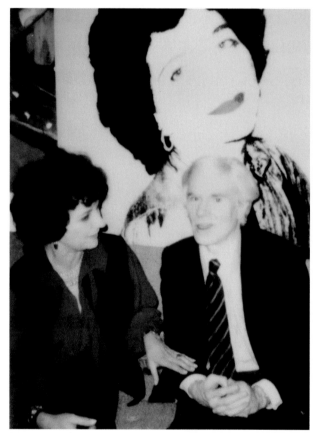

Patsy with Andy Warhol and Warhol's painting of Patsy,
circa 1970

Ray and Patsy with Ladybird Johnson (*top left*) and Rosylyn Carter (*top right*).
At bottom: Ray at the United Nations, 1967

Constantin Brancusi: *Bust of a Boy*, 1906, Bronze, 12 ¼ in. x 8 in. x 7 in.
The Nasher Collection can be viewed from several perspectives.
We chose two: heads and nudes.

Raymond Duchamp-Villon, *Baudelaire*, 1911, Plaster, 16 in. x 8 ⅞ in.
x 10 ⅛ in.

Henri Matisse: *Head with Necklace*, 1907, Bronze, 5 ⅝ in. x 5 ⅛ in. x 3 ¾ in.

Pablo Picasso: *Head* [*Fernande*], 1909, Plaster, 34 in. x 14 ⅜ in. x 19 ¼ in.

Constantin Brancusi: *The Kiss*, 1907-08, cast before 1914, Plaster, 11 in. x 10 ¼ in. x 8 ½ in.

Auguste Rodin: *Hanako*, 1908, Plaster, 6 ¾ in. x 4 ⅝ in. x 5 ½ in.

Raymond Duchamp-Villon: *Maggy*, 1912, cast 1957, Bronze, 28 in.
x 13 ¼ in. x 15 in.

Roy Lichtenstein: *Head with Blue Shadow*, 1965, Glazed ceramic, 15 in. x 8 ¼ in. x 8 in.

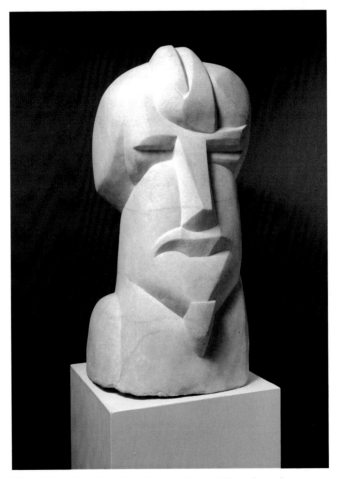

Henri Gaudier-Braeska: *Hieratic Head of Ezra Pound*, 1914,
Marble, 35 ⅝ in. x 18 in. x 19 ¼ in.

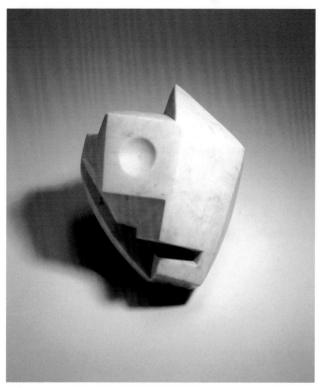

Alberto Giacometti: *Cubist Head*, 1934, Marble, 7 ⅜ in. x 7 ¾ in. x 8 ⅛ in.

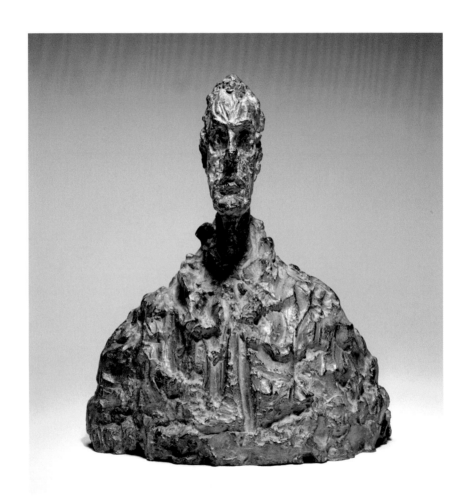

Alberto Giacometti: *Bust of Diego*, 1954, Painted bronze, 15 ½ in. x 13 ¼ in. x 8 ¼ in.

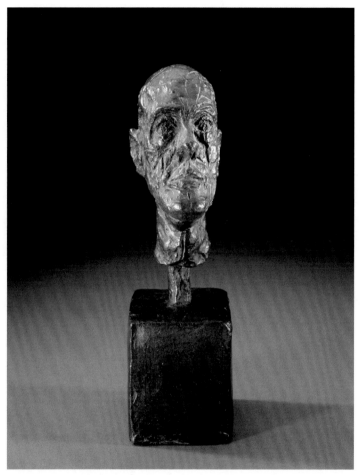

Alberto Giacometti: *Head of Diego on a Base*, 1958, Bronze, 12 in. x 3 ⅜ in. x 4 ¼ in.

Auguste Rodin: *The Age of Bronze*, 1876, Plaster, 71 ½ in. x 21 ¼ in. x 25 ½ in. (The following 11 pages feature nudes from the Nasher collection.)

Henri Matisse: *Venus in a Shell*, 1932, Bronze, 13 ⅜ in. 6 ⅞ in. x 9 ⅛ in.

Henri Matisse: *Reclining Nude (I) Aurora*, 1906–07, Bronze, 13 ¹⁄₁₆ in. x 19 ¾ in. x 11 in.

Henri Matisse: *Madeleine I*, 1901, cast 1903, Painted Plaster,
23 ¾ in. x 9 ½ in. x 7 ½ in.

Auguste Rodin: *Eve*, 1881, cast before 1932, Bronze,
68 in. x 17 ¼ in. x 25 ½ in.

Paul Gauguin: *Tahitian Girl*, 1896, Wood and mixed media,
37 ⅜ in. x  7 ½ in. x 8 in.

Henry Moore: *Reclining Figure: Angles*, 1979, cast 1980, Bronze, 4 ¼ in. x 30 in. x 19 ⁹⁄₁₆ in.

Gaston Lachaise: *Elevation*, 1912–27, cast 1964, Bronze, 70 ¾ in.
x 30 in. x 19 ⁹⁄₁₆ in.

Alexander Archipenko: *Woman Combing Her Hair*, 1914 or 1915, Bronze, 14 ⅛ in. x 3 ⅝ in. x 3 ³⁄₁₆ in.

Henri Matisse: *Decorative Figure*, 1908, cast early 1930s, Bronze, 28 ⅜ in. x 20 ⅜ in. x 12 ⅜ in.

Arsitide Maillol: *Marie*, 1930, Bronze, 27 in. x 8 in. x 13 in.

Aristide Maillol: *Night*, 1902–09, cast 1960, Bronze, 41 in. x 42 in. x 22 ½ in.

Antics Ruines, Herdonia, Italy

Renzo Piano

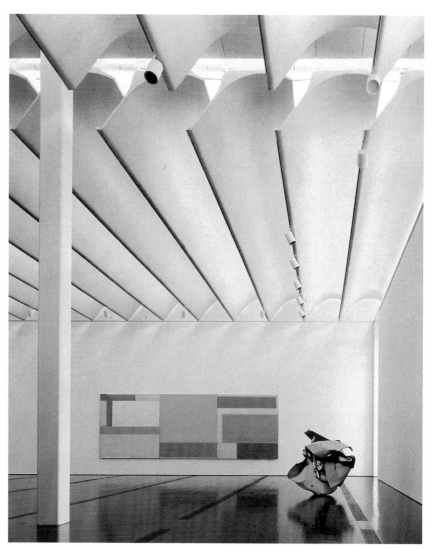

Ceiling in the Menil Museum

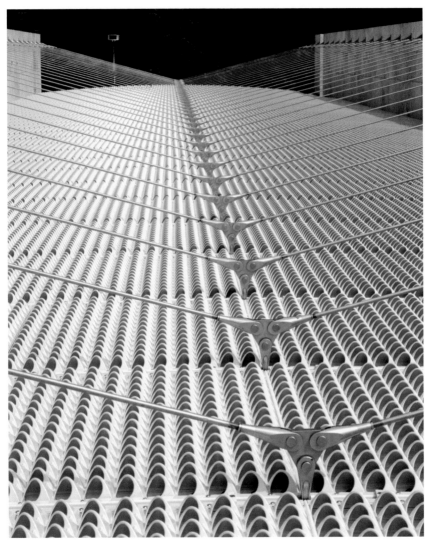

Roof of the Nasher Sculpture Center

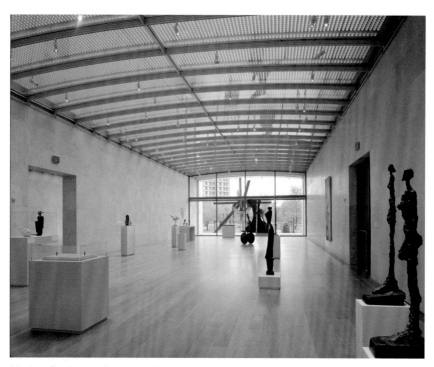

Nasher Sculpture Center—Giacometti Gallery

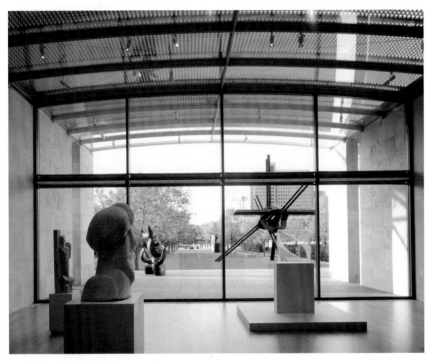

Nasher Sculpture Center—Gallery into Garden

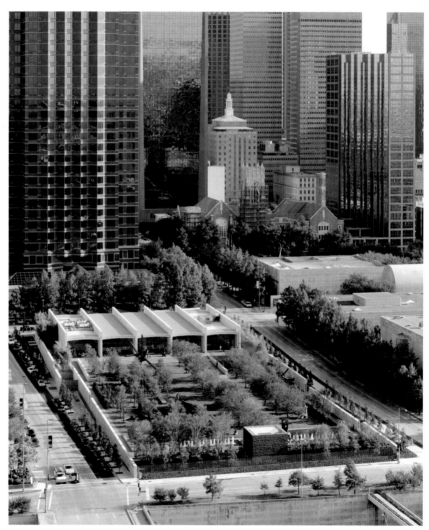

Nasher Sculpture Center—Aerial view from Woodall Rogers Freeway

Nasher Sculpture Center—Path from back of Garden

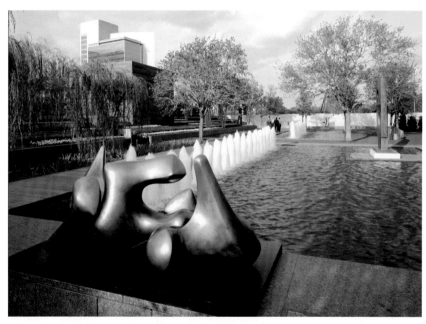

Nasher Sculpture Center—Moore with Reflecting Pool

Nasher Sculpture Center—Turrell's *Tending (Blue)*

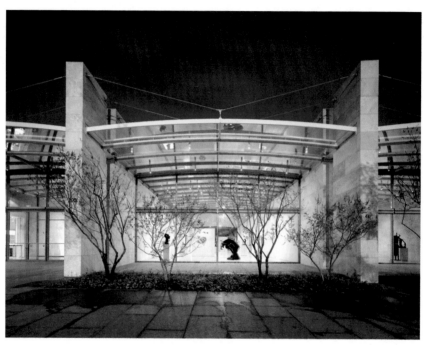

Nasher Sculpture Center—night shot

Patsy Nasher, 1928–1988

# CREDITS

Images from *Epitome of Desire* were reproduced by permission from the following persons and institutions: **Courtesy of the Nasher Family**: pages 4, 6–14, 16–17, 18 (John Haynesworth, photographer), 20 (courtesy of Mark di Suvero), 21, 26, 27, 63. **Courtesy of the Raymond and Patsy Nasher Collection, Dallas, Texas**: pages 2 (David Heald, photographer), 15 (courtesy of Beverly Pepper), 24 (Lee Clockman, photographer), 25 and 28–34 (David Heald, photographer), 35 (Tom Jenkins, photographer), 37–40, 42–44, and 46–51 (David Heald, photographer). **Courtesy of the RDN and PRN Foundation, Dallas, Texas**: pages 36, 41 and 45 (David Heald, photographer). **Courtesy of the Nasher Sculpture Center**: pages 3, 55–60 and 62 (Tim Hursley, photographer). **Courtesy of the Renzo Piano Building Workshop**: pages 52, 53 (Michel Dehahlé, photographer), 54. **Courtesy of *Duke University Magazine***: pages 22 and 23 (Chris Hildreth, photographer).

Every attempt has been made to secure permission to reprint copyrighted material. The following is a listing of copyright notices for works of art reproduced in this book:

The quotation from Williams Maxwell's book *The Outermost Dream: Literary Sketches* © 1989 by William Maxwell, reprinted with the permission of the Wylie Agency, Inc.; Jean Arp © 2004 Artists Rights Society (ARS), New York/VG Bild-Kunst, Bonn; Constantin Brancusi © 2004 Artists Rights Society (ARS), New York/ADAGP, Paris; Paul Cezanne *Farm in Normandy: The Enclosure*: Private Collection on Extended Loan to the Courtauld Institute of Art Gallery; © Mark di Suvero, Courtesy of the artist and Spacetime C.C.; Alberto Giacometti © 2004 Artists Rights Society (ARS), New York/ADAGP, Paris; © The Lachaise Foundation; © Estate of Roy Lichtenstein; Aristide Maillol © 2004 Artists Rights Society (ARS), New York/ADAGP, Paris; © 2004 Succession H. Matisse, Paris /Artists Rights Society (ARS), New York; the work illustrated on pages 46 and 60 has been reproduced by permission of the Henry Moore Foundation, © The Henry Moore Foundation; © Beverly Pepper; © 2004 Estate of Pablo Picasso/Artists Rights Society (ARS), New York; © 2004 Estate of Tony Smith/Artist Rights Society (ARS), New York; Turrell Diagram © Interloop A/D; Vincent van Gogh © 2003 Museum of Fine Arts, Boston.